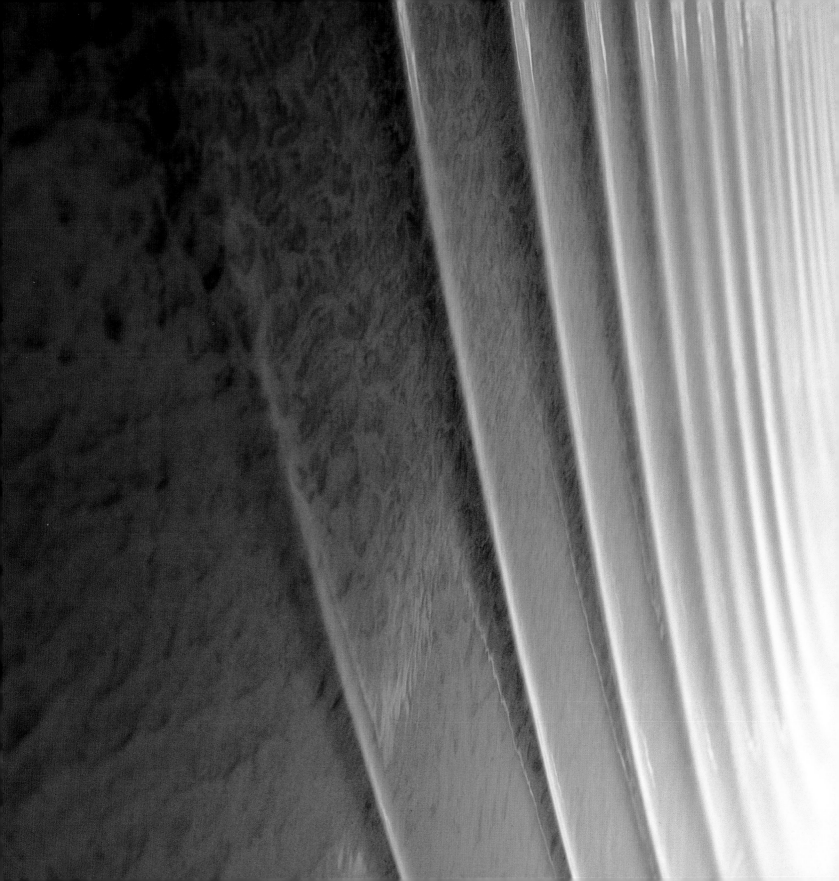

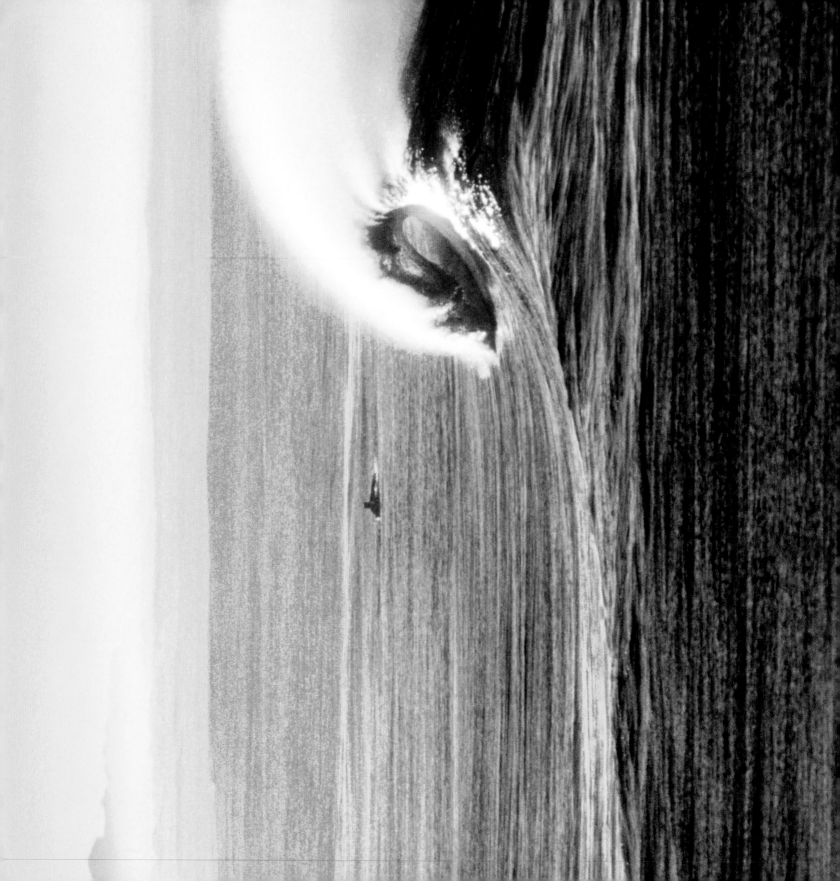

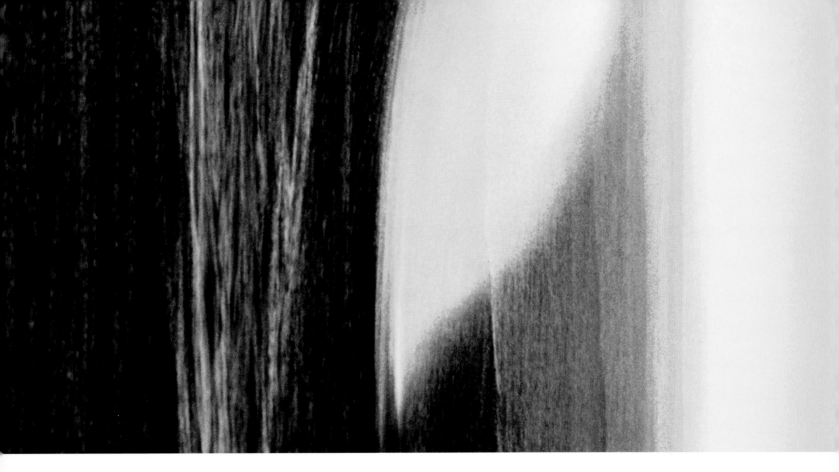

WAVES

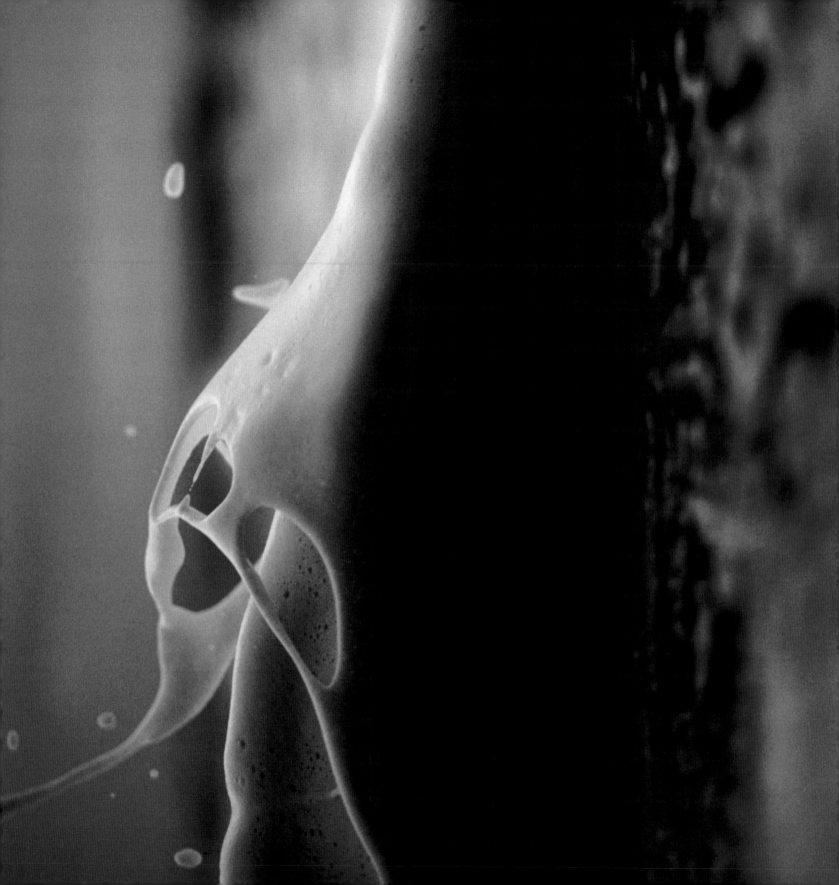

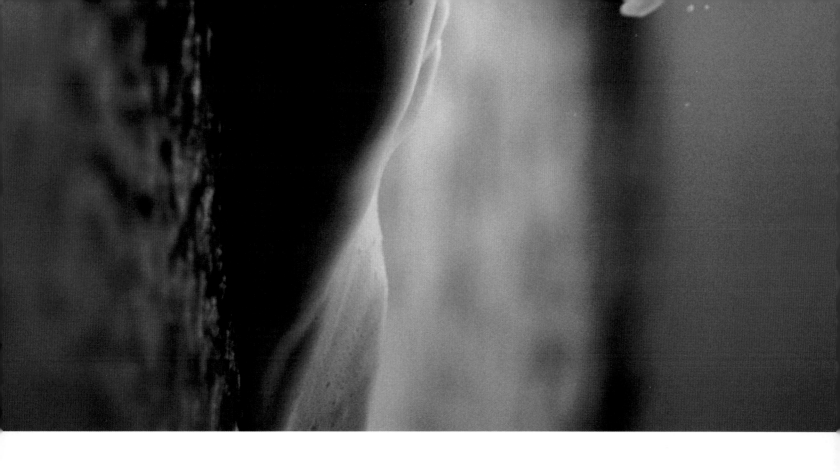

WAVES

BY **STEVE HAWK**

CHRONICLE BOOKS

SAN FRANCISCO

TEXT COPYRIGHT © 2005 BY Steve Hawk

All rights reserved. No part of this book may be reproduced in any form without written permission from the publisher. Page 130 constitutes a continuation of the copyright page.

Library of Congress Cataloging-in-Publication Data available.

ISBN: 0-8118-4517-6

MANUFACTURED IN Hong Kong

DESIGNED BY Ayako Akazawa

DISTRIBUTED IN CANADA BY Raincoast Books

9050 Shaughnessy Street

Vancouver, British Columbia V6P 6E5

10 9 8 7 6 5 4 3 2 1

Chronicle Books LLC

85 Second Street

San Francisco, California 94105

www.chroniclebooks.com

PAGE 1 **CARDIFF BY THE SEA, CALIFORNIA**
PAGE 2 **VENTURA COUNTY, CALIFORNIA**
PAGE 4 **STONE STEPS, LEUCADIA, CALIFORNIA**

For Nancy Hawk, whose generosity could fill an ocean.

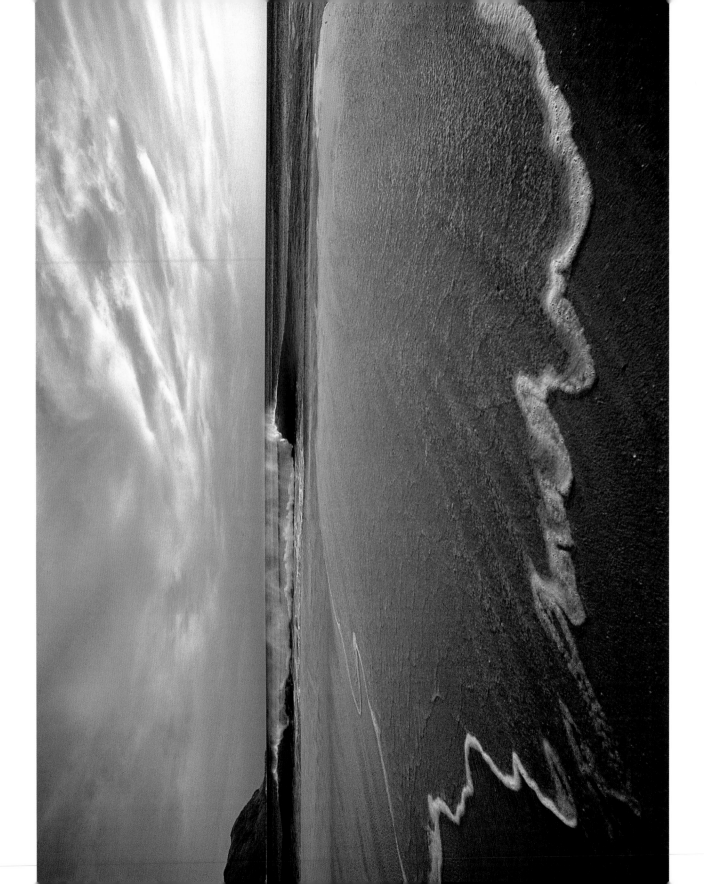

Anyone who has ever felt the punch of a breaking wave understands viscerally, although perhaps not intellectually, that he is toying with energy in its most fundamental form. Surfers know this better than anyone, of course, but unfortunately their knowledge of waves is so intimate and physical that they frequently sound like idiot savants when they try to describe them. This is what all surf-riders know in their bones: ocean waves are not moving humps of water but invisible pulses of power moving *through* water.

Waves frighten and thrill us for many reasons. When we swim among them, the sensory input can overwhelm: the maritime scents, the water's salty sting, the roar of a collapsing crest, the pull of currents, the fear of being held under. But nothing grips our senses more tightly than the power and beauty of the waves themselves. They are the reason why a landlubber from, say, Omaha, will sit dumbstruck for hours watching the water undulate. And they are why most surfers surf for life.

Someone with a mystical bent might even argue that humans possess a molecular attraction to surf. Waves are a unifying element in the universe, perhaps *the* unifying element. They sit at the center of the mysterious phenomenon known as "quantum weirdness"— the discovery that waves sometimes act like particles and particles sometimes act like waves. In 1926, Erwin Schrödinger worked out the equation that explained the behavior of so-called particle waves, but it was Louis de Broglie who became a hero to surf rats with his countertheory that all matter has a wavelength and, thus, "all of nature is a great wave phenomenon."

From a physicist's viewpoint, the turquoise swells surging over a Fijian reef are essentially the same as the sound waves that travel from a woofer to your eardrum, or the light waves that travel from Orion's Belt to your retina. Once the sea breeze kicks up a wave "train," the swells therein move as predictably as billiard balls. They can be reflected, diffracted, and focused. They decay.

Unlike most waves that impact our lives, however, ocean waves move at user-friendly speeds. While sound waves boom through the air at 761 miles per hour, and light waves, at 671 million miles per hour, define the upper limit of velocity, an ocean wave moseys about as fast as a person can run. Out on the ocean, you can see each wave, each pulse, as it moves through the universe. It is the Schrödinger equation writ large: a subatomic principle magnified to a scale even Jeff Spicoli could grasp.

All this talk of velocity and subatomic equations, however, belies the purpose of this book: to illustrate the many shapes, textures, impacts, and hues—the visual drama—of ocean waves as they interact with the shore. "Wave-related permutations remain incalculable," Matt Warshaw wrote in *The Encyclopedia of Surfing*, "while the final outcome—a breaking wave—remains breathtaking."

Despite their mathematical predictability, breaking waves come in an endless array of forms and colors, shaped by ever-changing influences: the topography of the sea floor, the span—or period—between swells, the height from crest to trough, the speed and direction of the wind, the angle of the sun, the color of the reef, the location of the observer, and on and on and on. Seen from the right spot on the right day, a glassy fifty-foot peak at Maverick's in Northern California will look almost inviting, while wind-blown waist-high shore break, if thick and murky enough, will appear as deadly as a mudslide. And yet at the core they are the same, from a crystal six-inch tropical lapper to a thirty-foot groundswell powering through a sea of Antarctic ice: packets of pure energy, created by wind and transmitted through water.

A final word about the people who created the images in this book. Almost all of the photos gathered here were taken by professional surf photographers, a passionate and largely impoverished band of sea-shackled artists. Most of them have spent thousands of hours taking pictures of surfers, and surfing themselves. Their bond with the sea pervades their work, and they appreciate, perhaps more than anyone, the aesthetic potential of waves. They

OURS, SYDNEY, AUSTRALIA

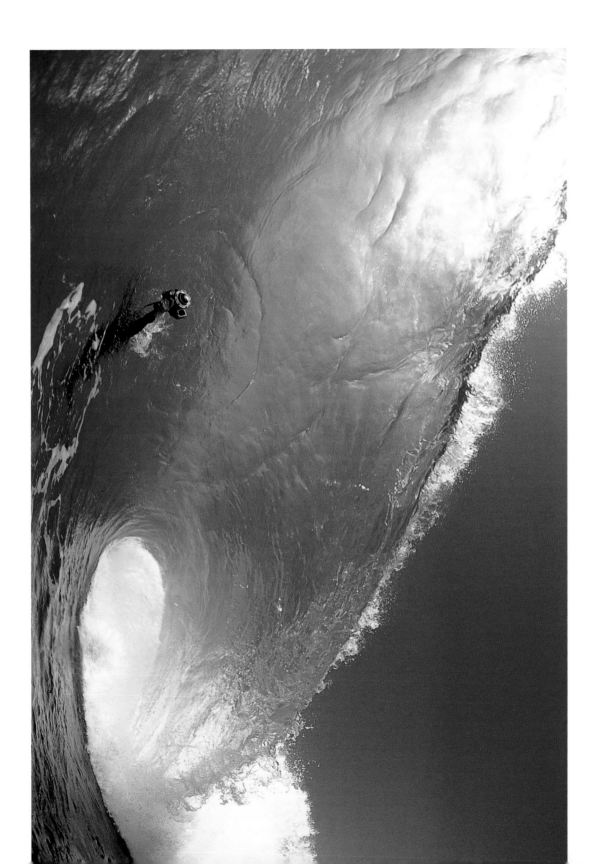

combine a landscape photographer's eye for natural beauty with a photojournalist's skill for capturing action. Often they swim out to the impact zone with a waterproof camera and immerse themselves in their art, hoping the subject doesn't pummel them before they get the shot. In the end this book is theirs.

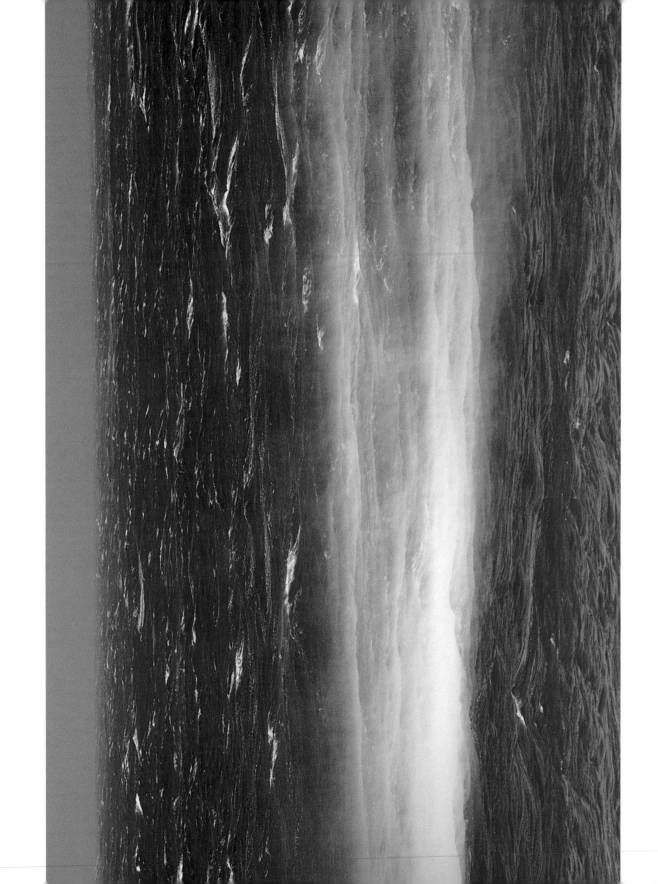

All surf owes its existence to the sun. Solar heat produces regions of varying pressures in the Earth's atmosphere. The flow between these pressure zones creates wind, and wind creates waves.

When a breeze blows across a stretch of sea, the resulting friction stirs up tiny triangular fluctuations on the water's surface, known to sailors as *cat's paws* and to scientists as *capillary waves*. Ripples arise, friction increases, and the wavelets enlarge. As newer and bigger waves amass, the rate at which the wind conveys its power to the ocean expands exponentially. At the same time, the waves themselves merge and intensify, and out of this chaotic field of white caps and sea spray emerges a parade of long, evenly spaced swells.

After a wave train (or swell) advances beyond its windy birthplace, it grows more orderly by the mile. A large, well-organized swell will march thousands of miles across the ocean without further aid from the wind, moving at a typical rate of about twenty-five miles per hour. Once ashore, a swell can last hours or days, depending on the duration of the wind that created it. As an individual wave nears landfall, it slows as it drags along the bottom, bending and warping according to the shape and location of submerged ridges, canyons, sandbars, reefs, and the like. Finally, when the water is shallow enough (about 1.3 times the wave height), the swell decelerates to the point where the top spills over. The wave basically trips: the lip pitches up and out, gravity pulls it back down, and the silent swell becomes surf.

This is when waves start to get interesting—and dangerous. On the open sea, with no wind, a toddler on a body board would be perfectly safe floating over one-hundred-foot swells; he'd rise and fall in big happy circles. Shove the same kid into shallow water during a four-foot south swell at the Wedge in Newport Beach—where the waves bounce off a jetty, join forces, and explode on the beach—and you'd get arrested for attempted murder.

ABOVE **GREAT OCEAN ROAD, VICTORIA, AUSTRALIA**
RIGHT **VENTURA COUNTY, CALIFORNIA**

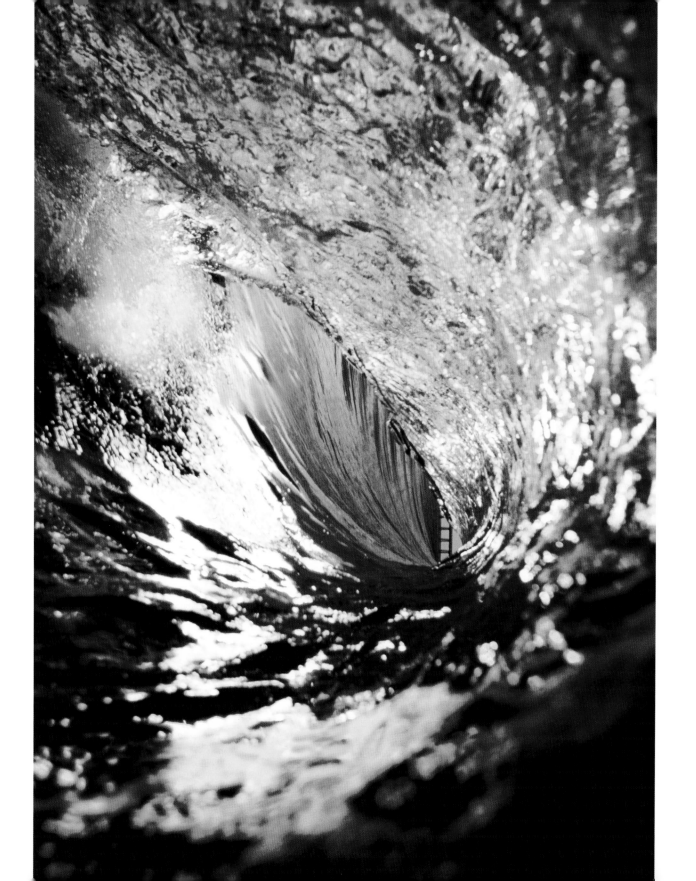

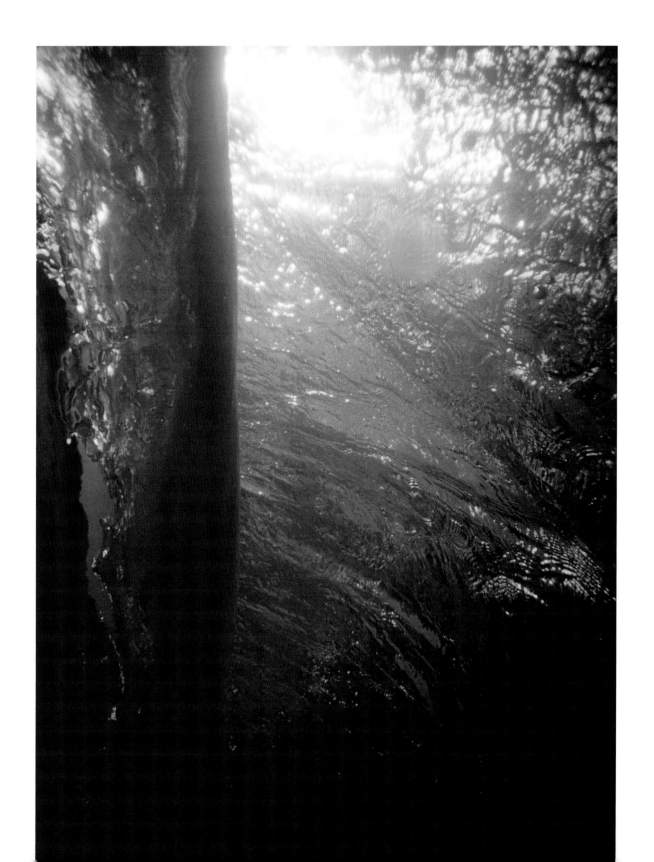

PALM BEACH, NEW SOUTH WALES, AUSTRALIA

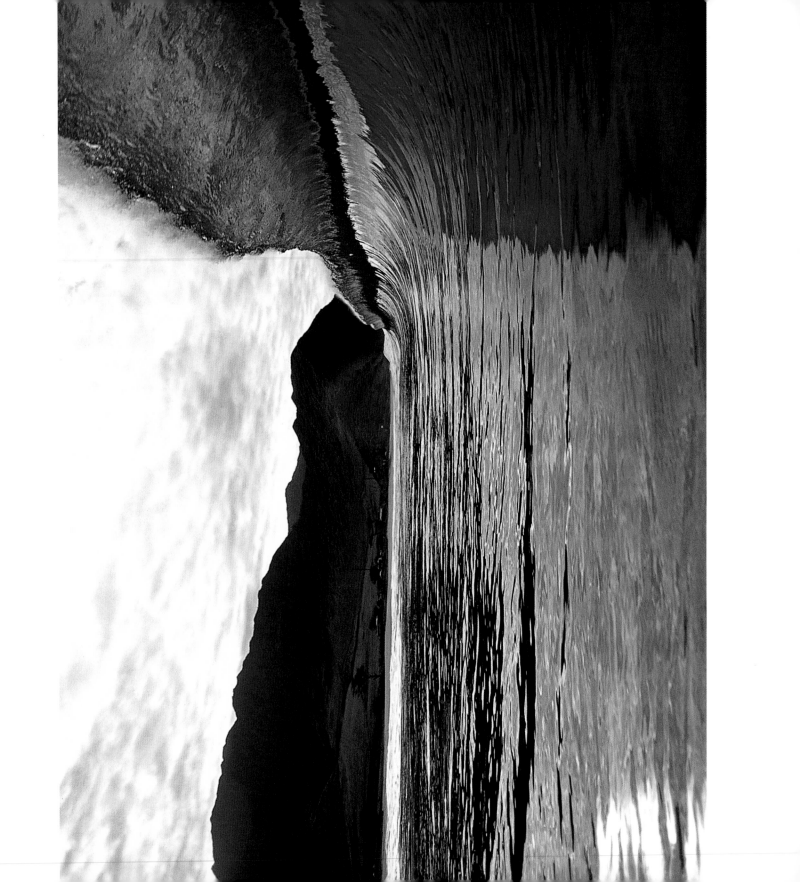

I DON'T KNOWS, OAHU, HAWAII

Still photographs expose details of breaking waves that spectators never see: the gentle dimpling of droplets falling from the fringe of a murderous lip; the uniform vertical ridges etched into a heaving wall by offshore wind; the elegant fingers of white water reaching into space as a dying wave pushes over a berm of sand.

In the end, though, a surf photo falsely represents the thing itself. Waves by definition exist in motion. Physicists can calculate theoretical slices of an ocean wave (its amplitude, its position, the distance between it and its nearest counterparts), and photographers can freeze an instant in its life. But to appreciate the way waves work, you have to see them in action.

The passionate oceanographer Willard Bascom, in his influential 1964 book *Waves and Beaches: The Dynamics of the Ocean Surface*, described it thus: "But now, full of confidence that we understand waves both in theory and by actual test, we fling open the laboratory door, stride to the edge of the cliff and look to sea. Good grief! The real waves look nothing like the neat ones . . . that march across the blackboard in orderly equations. These waves are disheveled, irregular, and moving in many directions.

"Should we slink back inside to our reliable equations and brood over the inconsistencies of nature? Never! Instead we must become outdoor wave researchers. It means being wet, salty, cold—and confused."

20

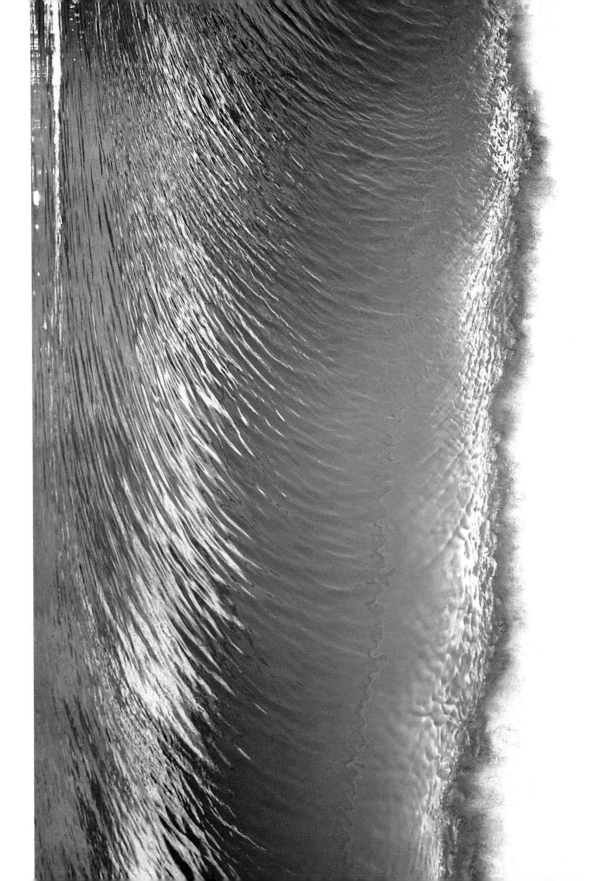

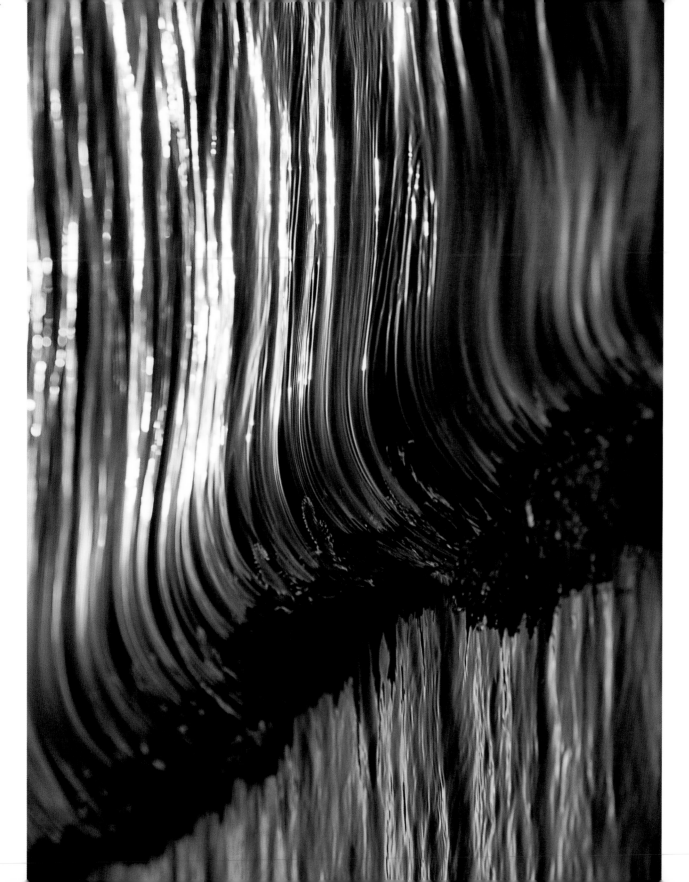

EHUKAI BEACH PARK, OAHU, HAWAII

NORTH NARRABEEN, NEW SOUTH WALES, AUSTRALIA

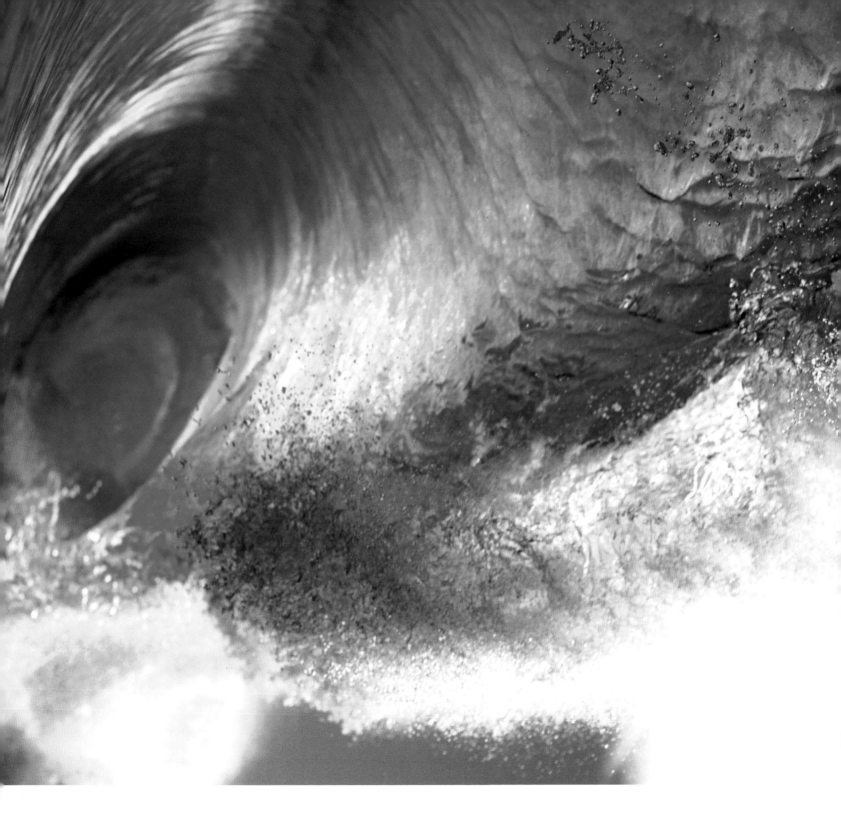

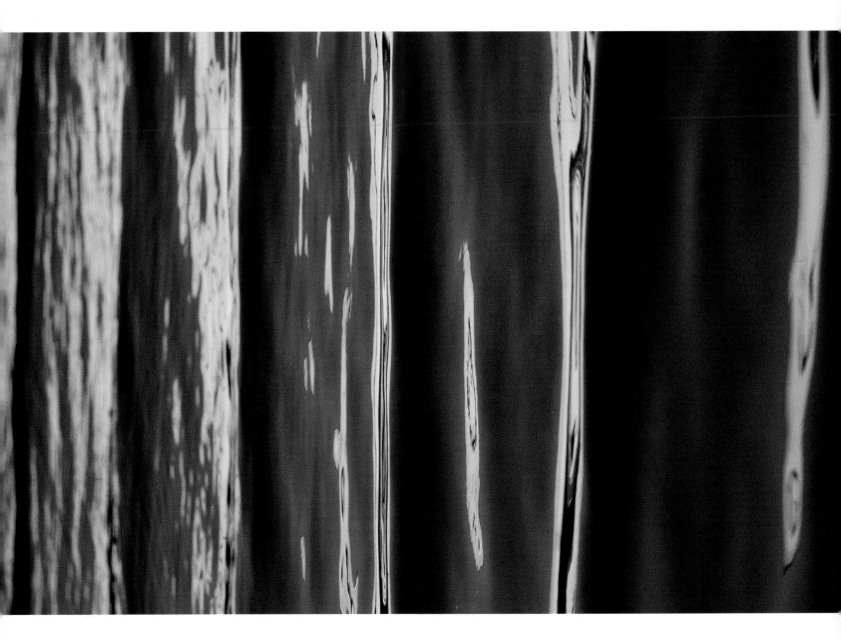

LEFT **ILUKA, NEW SOUTH WALES, AUSTRALIA**

BELOW **WAIMEA BAY, OAHU, HAWAII**

Wind gives birth to waves; it also either polishes or mars them in the final, climactic seconds when they reach shallow water and die. An offshore wind—one that blows from land to ocean—can create visual drama. When a swell vaults into a strong headwind, plumes of spray shear seaward from the arcing lip; if the sun cooperates rainbows can appear in the droplets. As long as it's not too strong, an offshore wind produces nearly ideal conditions for surfing, smoothing away chop and ballooning the surf into cylinders.

In Southern California, Santa Ana winds—famous for spreading the brushfires that level towns—bring the most memorable offshore conditions. As a result, the region's best surf sessions often coincide with catastrophe. In October 2003, while California wildfires killed twenty-two people and burned thirty-six hundred homes, surfers from Point Loma to Point Conception frolicked in a solid Southern Hemisphere swell groomed by consistent easterly winds, the sunset blotted by smoke, the water discolored by ash.

Conversely, onshore winds, which blow from the ocean toward land, disfigure the surf, chopping the surface into glary chaos. Surfers sulk or take up kitesurfing. While not as dreamy as an offshore breeze, an onshore gale can be dynamic and spectacular, whipping up a seascape of whitecaps and mist.

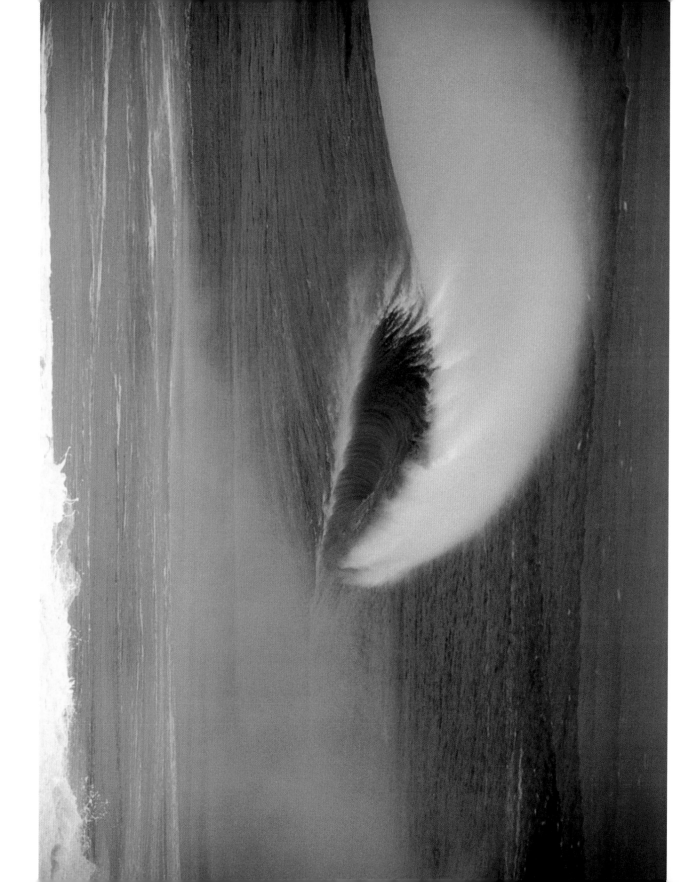

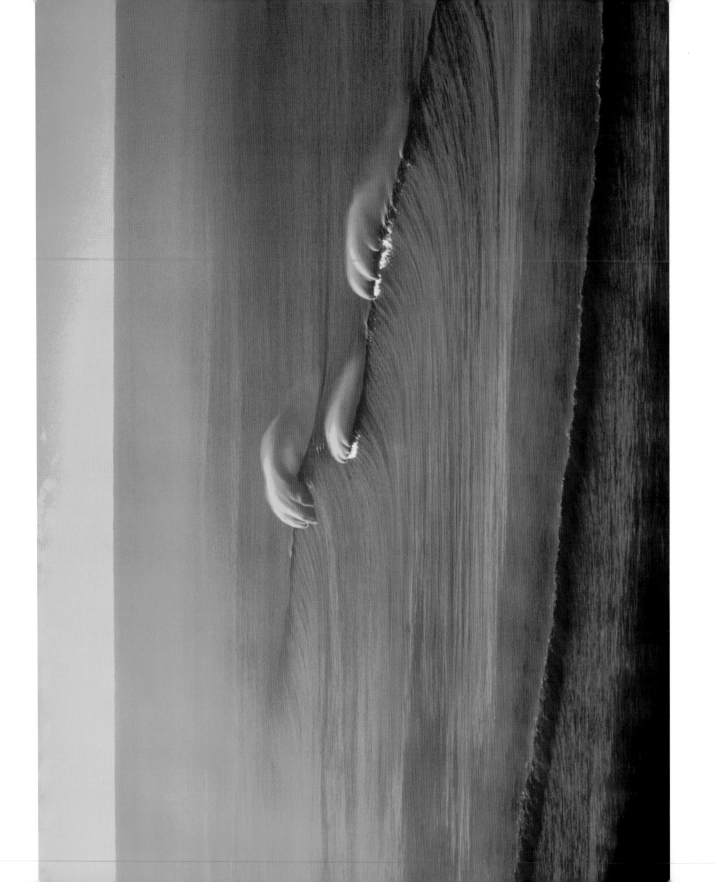

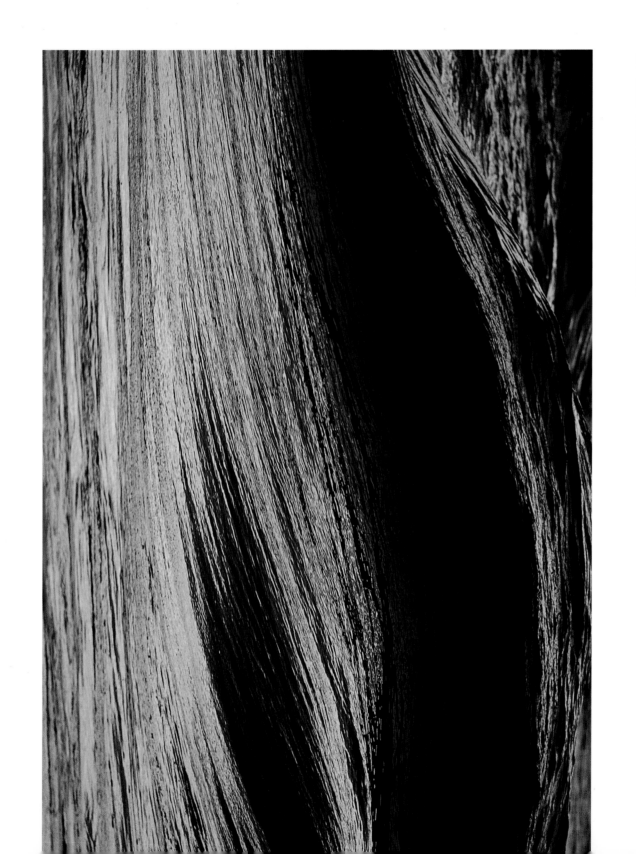

LEFT **GREAT OCEAN ROAD, VICTORIA, AUSTRALIA**

BELOW **WEST CLIFF DRIVE, SANTA CRUZ, CALIFORNIA**

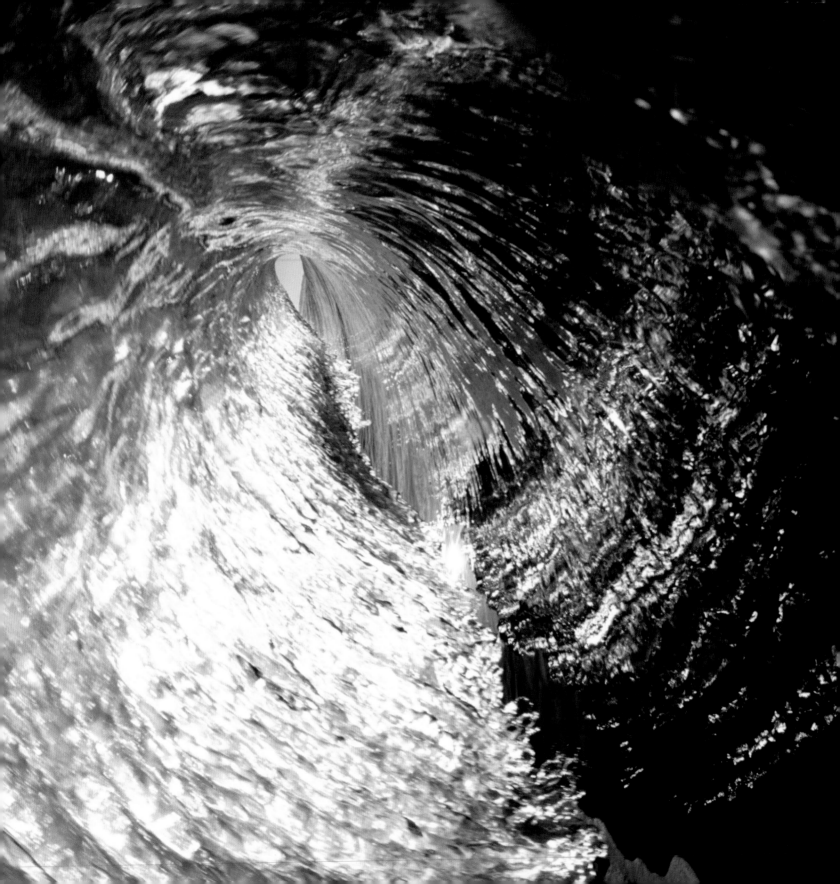

How powerful are waves? The answer to that question is largely theoretical and often subject to hyperbole. ("If you could harness the energy of even one of these waves," Bruce Brown said of the giant winter surf at Waimea Bay in his narration to the seminal surf movie *The Endless Summer*, "you could light a city for a week.")

Waves are muscular, to be sure, and their strength grows exponentially with their height. The wave-energy equation, as presented by pioneering oceanographer Willard Bascom, looks like this:

$$\varepsilon = \frac{wLH^2}{8}$$

where L is the wave length (distance between crests), H is the height, and w is the weight of a cubic foot of water, or 64 pounds. Using this equation, a 4-foot swell with a ten-second period (which translates to about 512 feet between crests) contains about 65,000 foot pounds of energy per linear foot. If the period remains the same but the wave height doubles to 8 feet, the energy increases fourfold, to 262,000 foot pounds.

On January 28, 1998, a buoy near Hawaii recorded wave heights of 27 feet with an average period of twenty seconds (or 2,048 feet) between swells. The resulting surf on Oahu's north shore was some of the biggest ever ridden. Plug those numbers into the wave-energy equation above, and you'll see that the power generated by a twelve-inch-wide vertical slice of one of those waves equaled about 11.9 million foot pounds.

Maybe Bruce Brown was right.

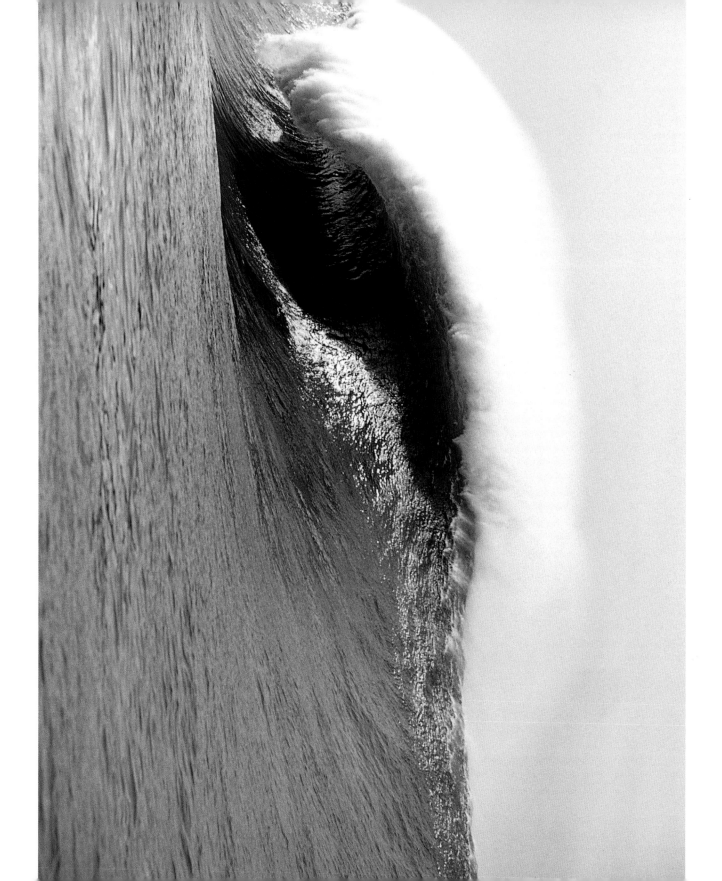

BELOW **TEAHUPOO, TAHITI**
RIGHT **WAIMEA BAY, OAHU, HAWAII**

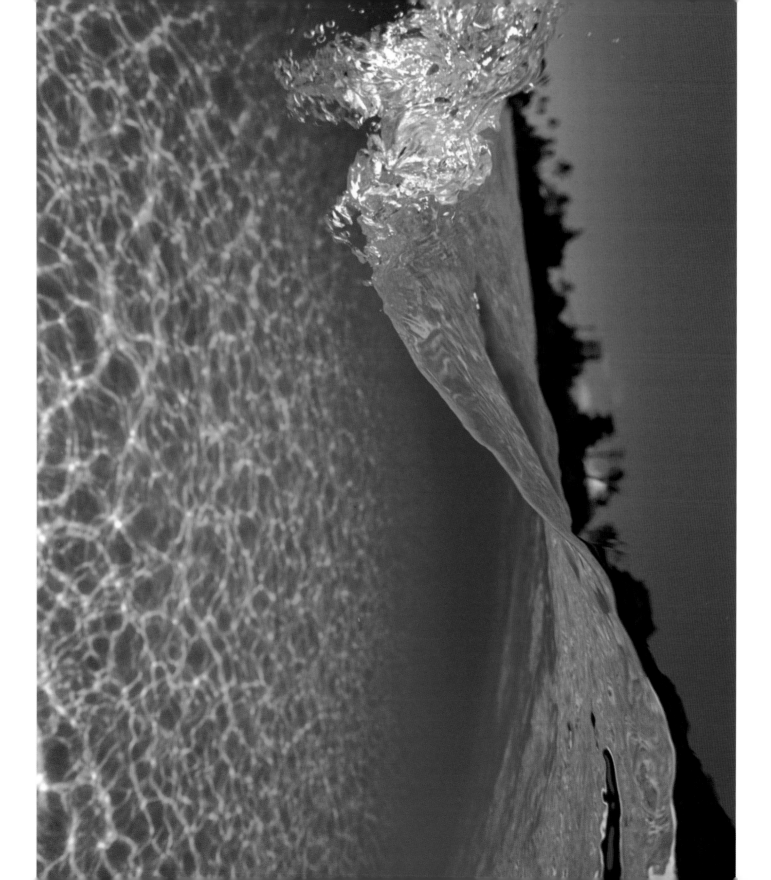

ST. JEAN DE LUZ, FRANCE

WAIMEA BAY, OAHU, HAWAII

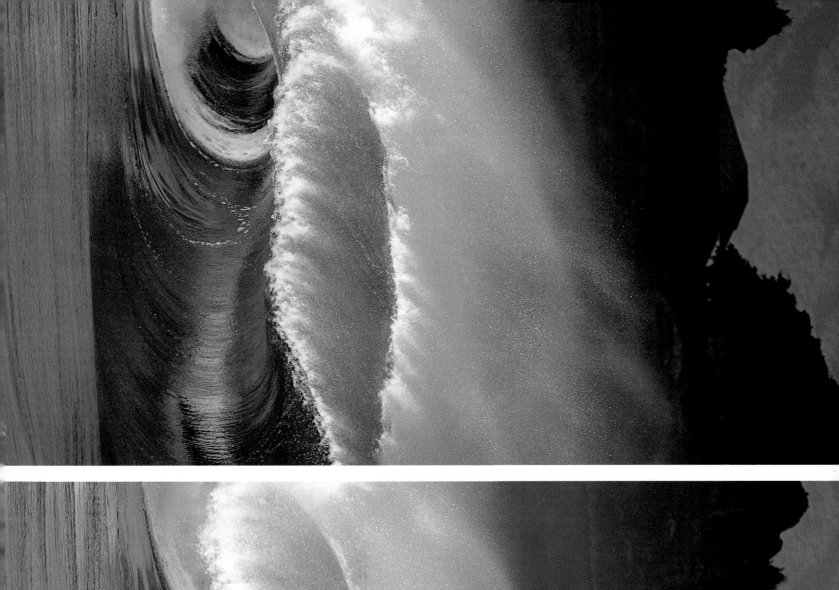
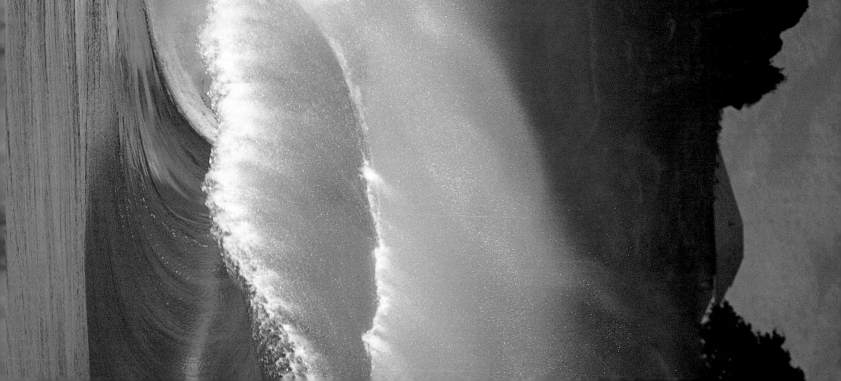

NEAR TEAHUPOO, TAHITI

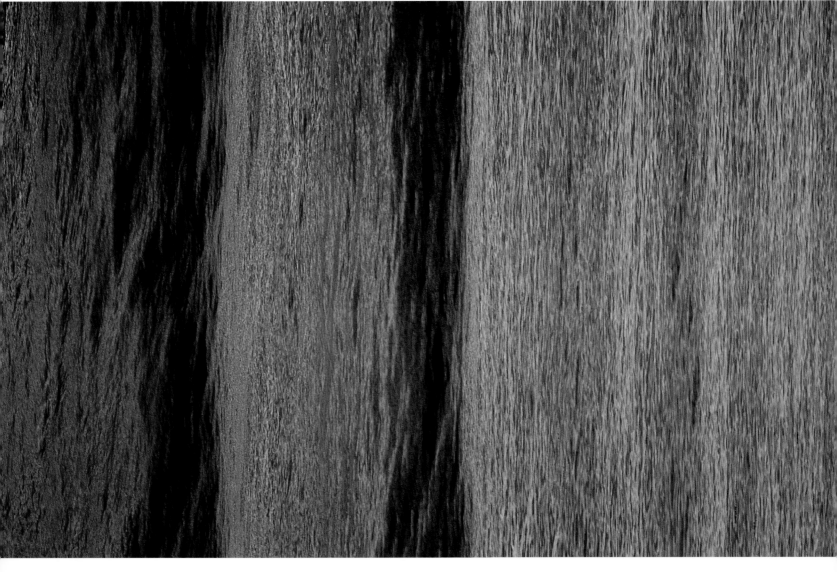

ST. ANN'S, SHELL BEACH, CALIFORNIA

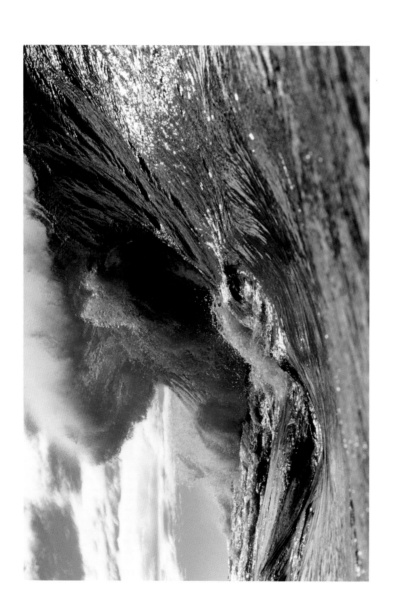

ABOVE **NORTH NARRABEEN ROCK LEDGE, NEW SOUTH WALES, AUSTRALIA**
RIGHT **SUNSET BEACH, OAHU, HAWAII**

VENTURA COUNTY, CALIFORNIA

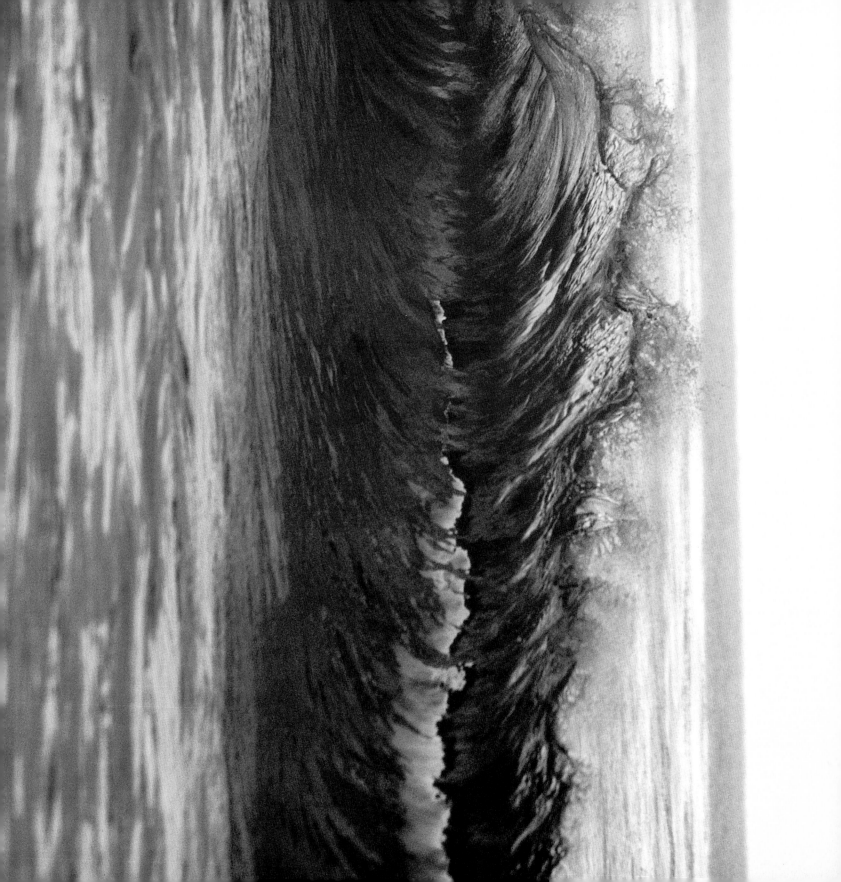

When a wave reaches shore and encounters a cliff face or a steeply sloped beach, the resulting impact doesn't exhaust the swell's energy. It simply reverses its direction. Just as light reflects off a mirror and sound echoes off walls, the swell ricochets against the obstruction and heads back to sea. The outgoing wave, known as *backwash*, often slams head-on into an incoming breaker, warping bizarre mutations in the wave face and flinging sheets skyward.

This oceanic clash can catapult wave riders high into the air, leaving them scared but usually unscathed. Because backwash explosions tend to happen near shore, a handful of well-known beaches (most notably the Wedge in Newport Beach, California; Makaha on the west coast of Oahu, Hawaii; and Cape Kiwanda in Oregon) draw hordes of sightseers when swell and tide align.

CAPE KIWANDA, OREGON

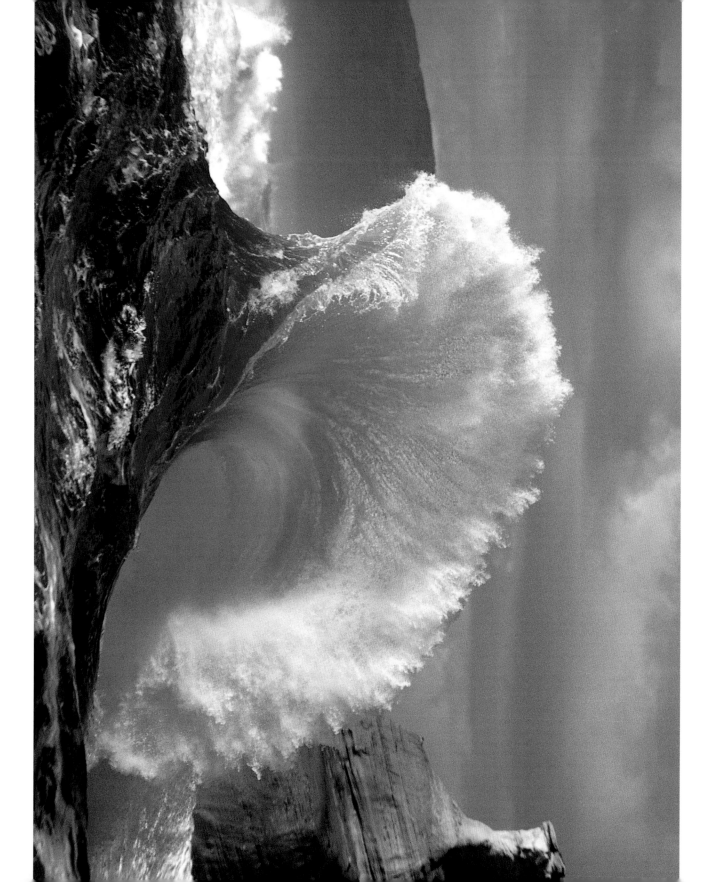

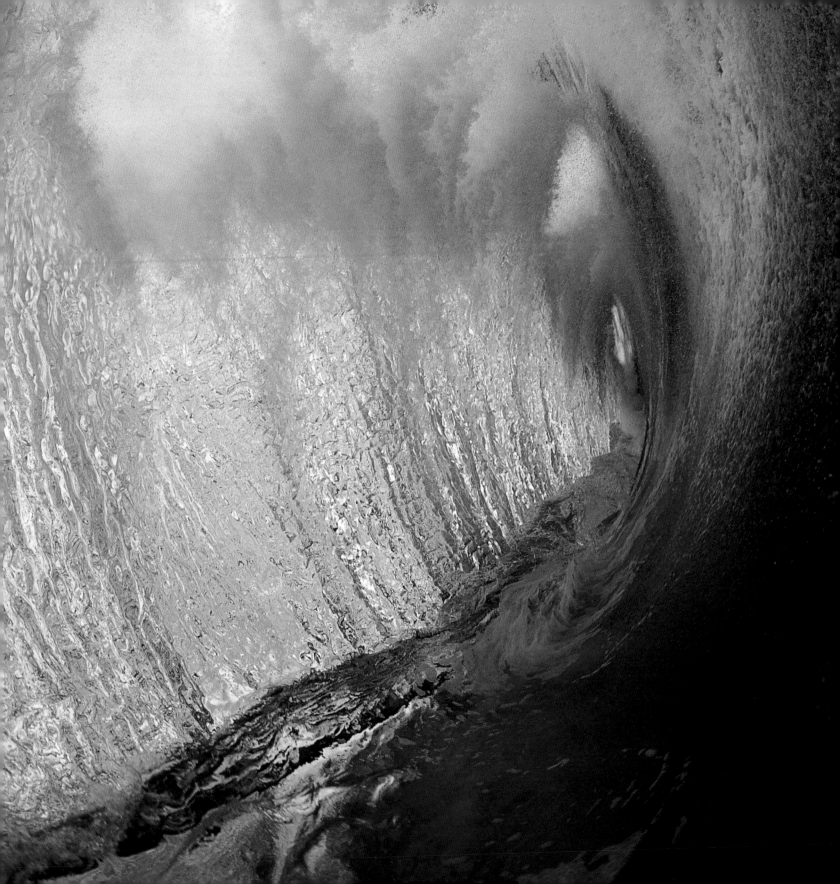

BACKDOOR, OAHU, HAWAII

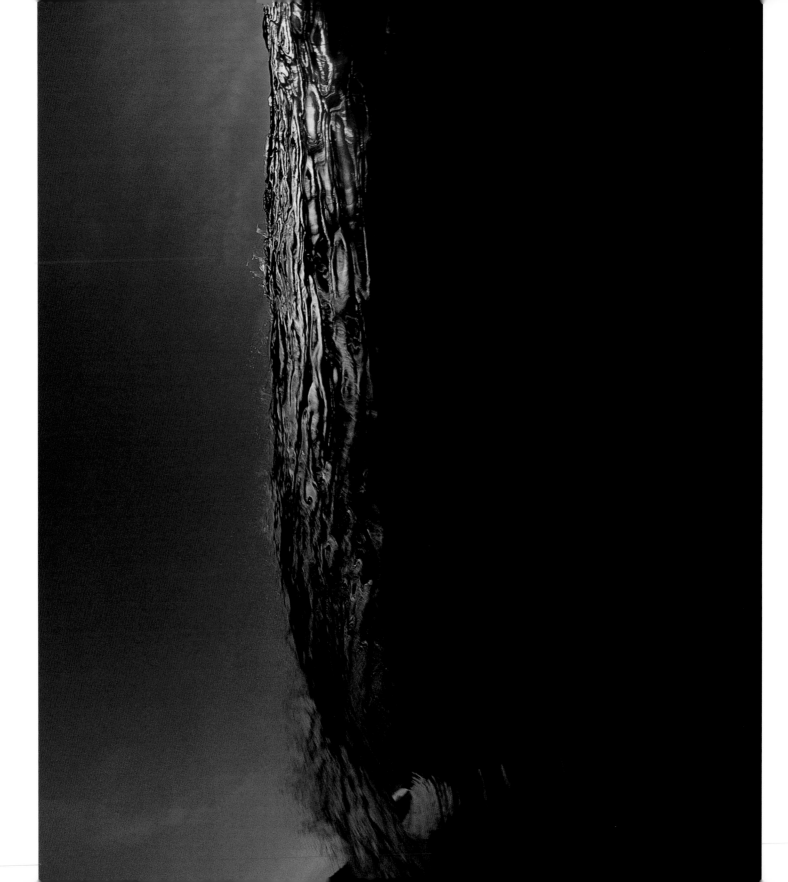

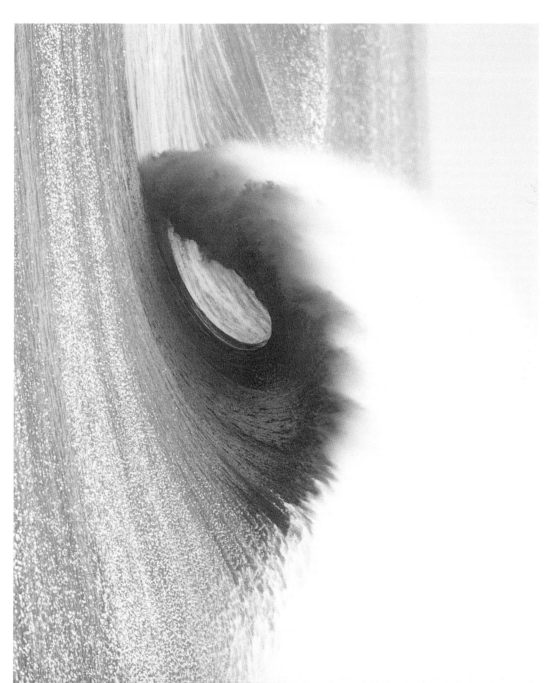

ABOVE **VENTURA COUNTY, CALIFORNIA**

LEFT **STRANDS, DANA POINT, CALIFORNIA**

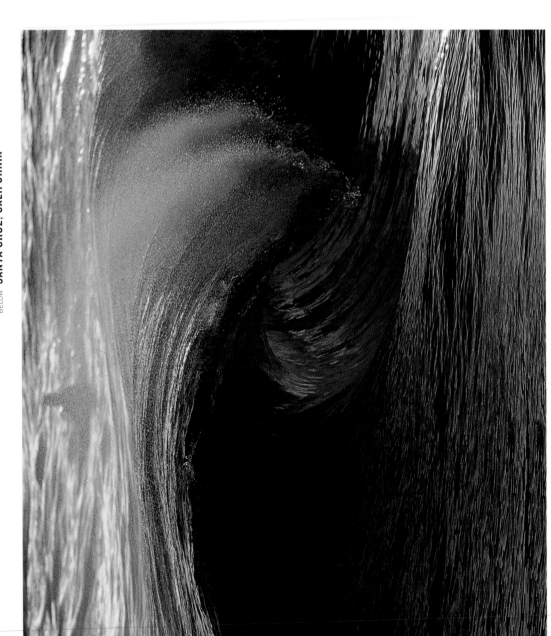

RIGHT **PIPELINE, OAHU, HAWAII**

BELOW **SANTA CRUZ, CALIFORNIA**

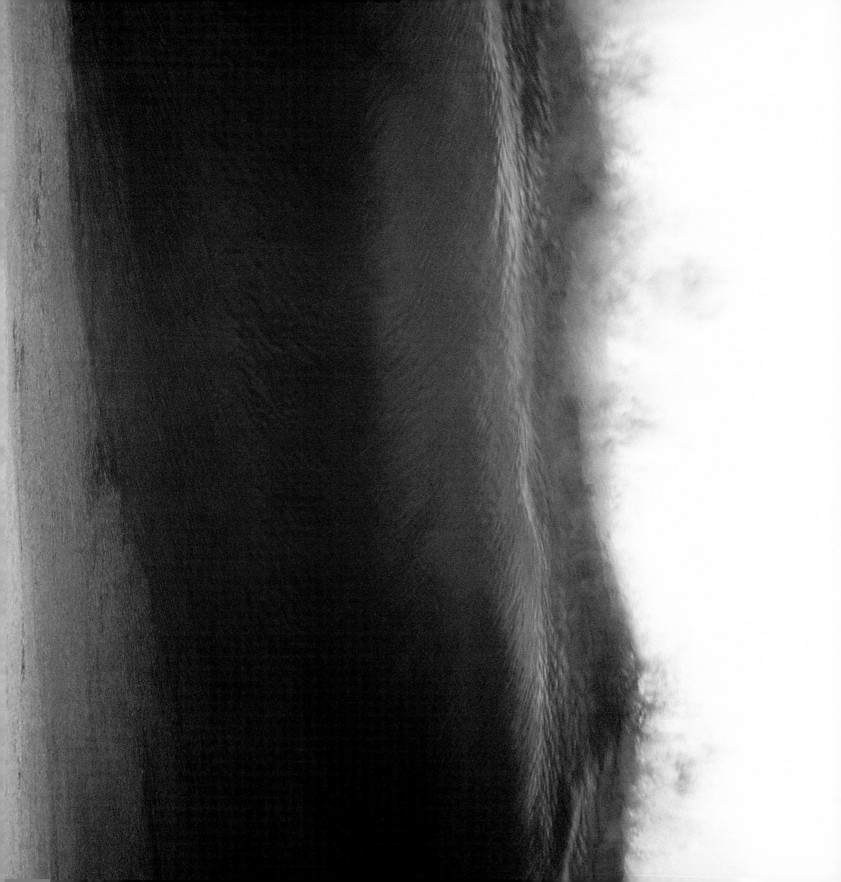

Perhaps no surf spot on Earth displays the mood swings of Waimea Bay, on Oahu's North Shore. The bay is most famous for its huge waves, which are surfable up to thirty-five feet and have appeared in innumerable films and photos since surfers first rode them in 1957.

During heavy winter swells, the bay becomes a multimonster horror show. The place where big-wave surfers ride, at the east end of the bay, surges and topples like a brick high-rise in a 9.0 quake. The inner shorebreak is smaller but nastier, a bouncy, bone-crushing triple-decker that unloads almost directly onto dry sand. To the west, windswept peaks break alluringly in deeper, safer water and then seem to gain momentum on their way to shore, where they thunder into a no-man's-land of pinnacles and cliffs.

In summer, however, when North Pacific swells subside, Waimea's quiet, crystalline water and bone-white sand beckon. Tourists answer the call, floating on the lakelike bay in bliss, unaware of the wintertime war zone.

WAIMEA BAY, OAHU, HAWAII

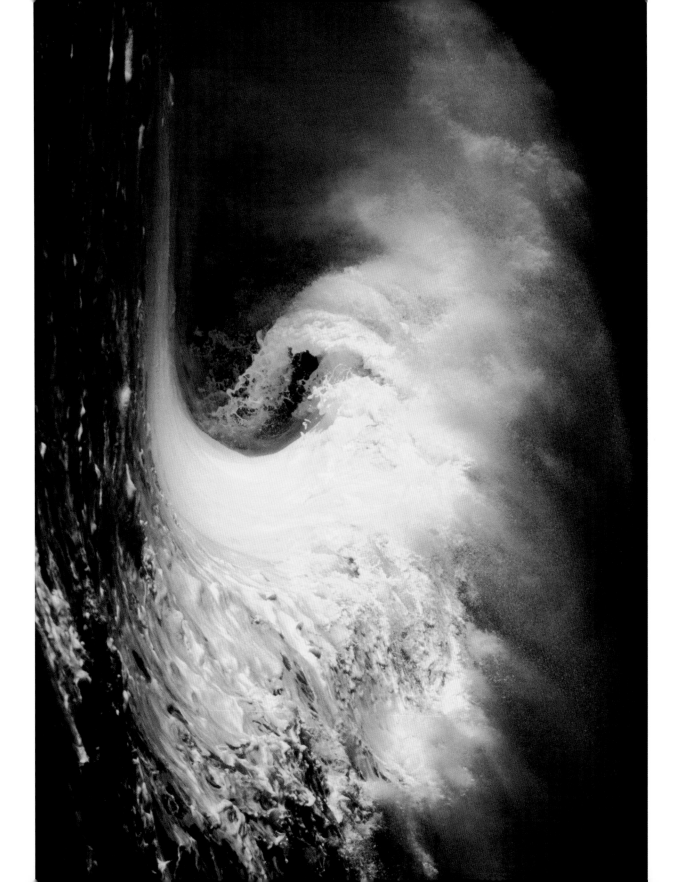

WAIMEA BAY, OAHU, HAWAII

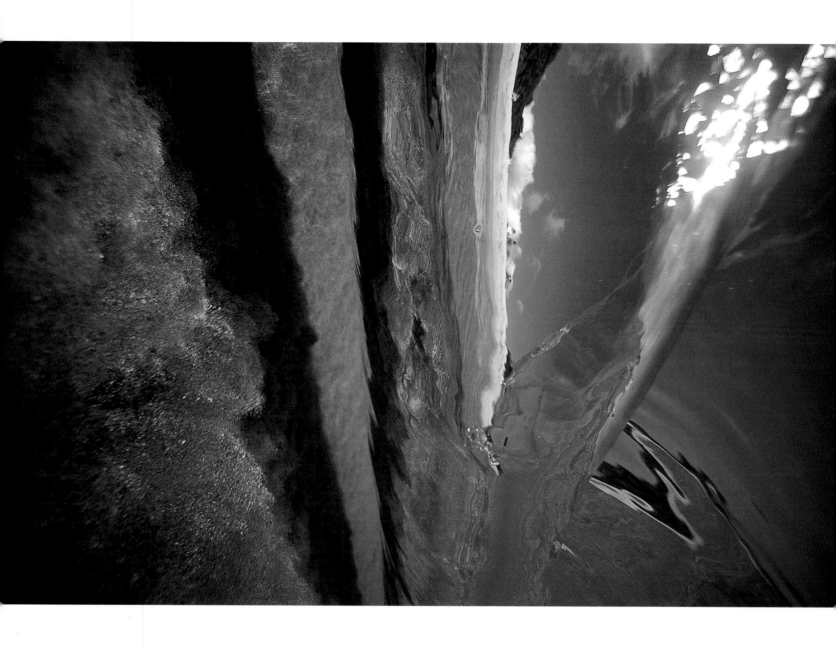

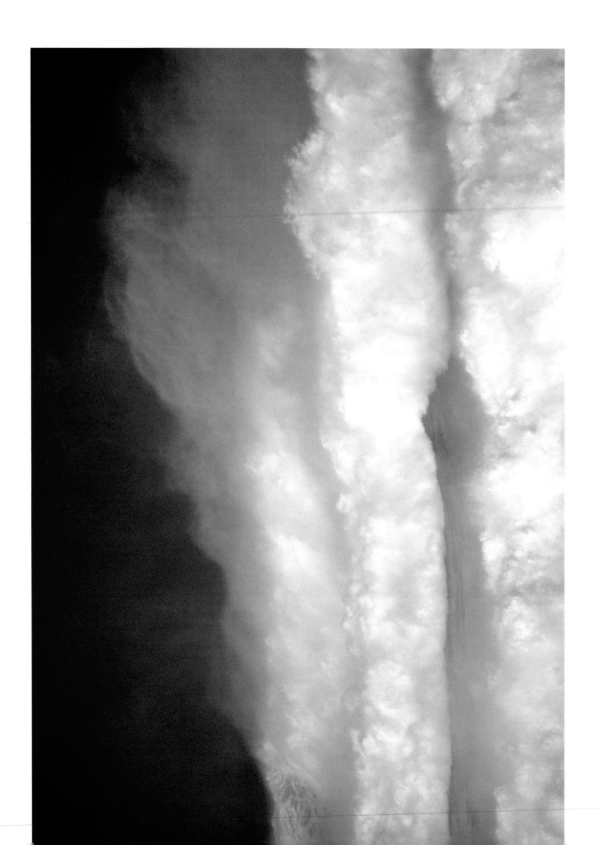

WAIMEA BAY, OAHU, HAWAII

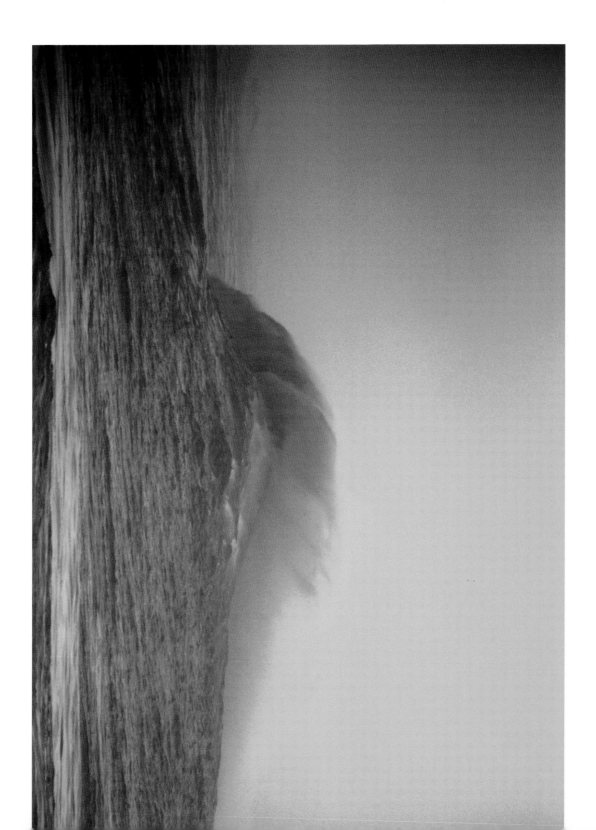

WAIMEA BAY, OAHU, HAWAII

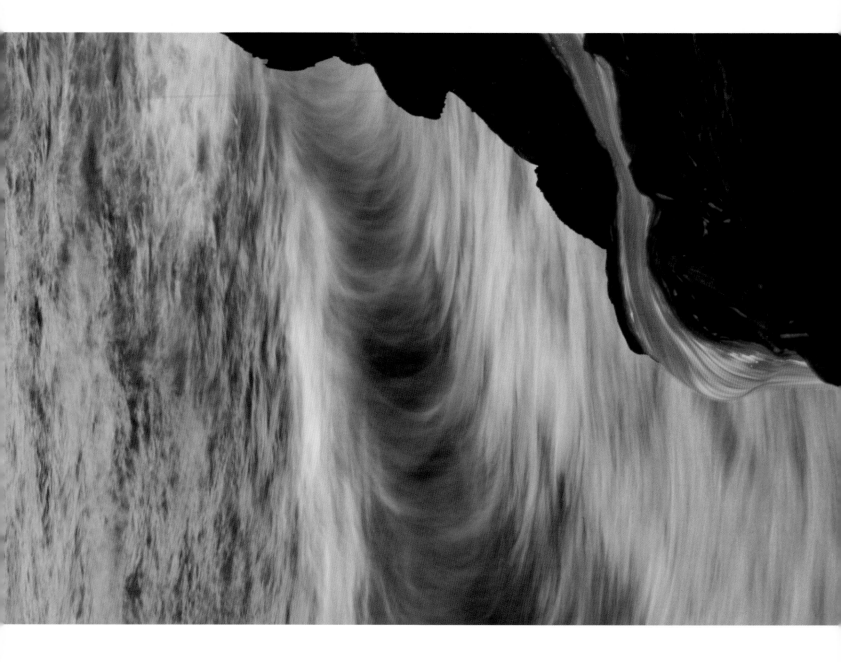

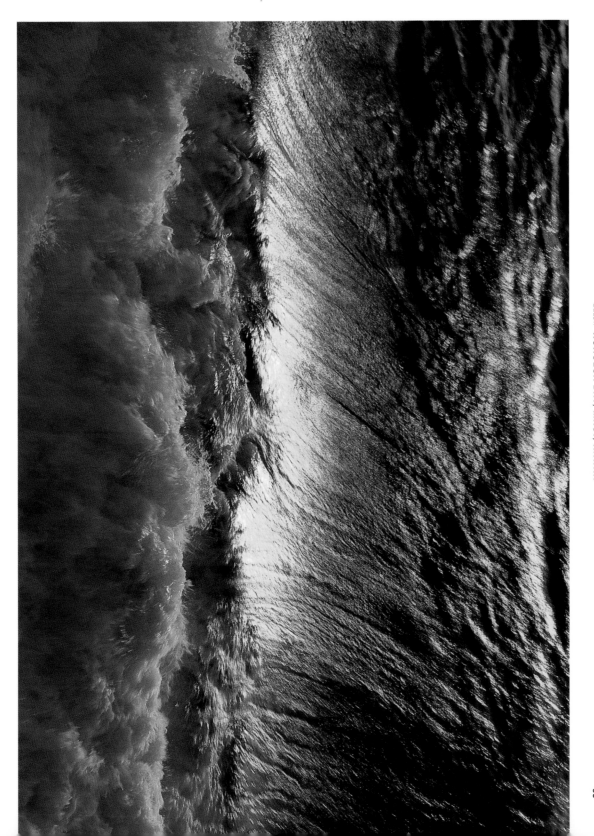

LEFT **KAMOAMOA, HAWAII VOLCANOES NATIONAL PARK, HAWAII**

BELOW **HONOLUA BAY, MAUI, HAWAII**

It would be difficult to overstate the erosive and destructive capacity of surf. Time-lapse footage of almost any shoreline in the world would reveal bluffs in retreat, structures under siege, and beaches that come and go like seasonal snowpack.

"No other force of equal intensity so severely tries every part of the structure against which it is exerted, and so unerringly detects each weak place or faulty detail of construction," U.S. Army Engineer D. D. Gaillard wrote one hundred years ago in a government paper titled *Wave Action in Relation to Engineering Structure*.

Because of their treacherous placement, lighthouses and seawalls take the hardest hits. In 1877, violent surf ripped apart the breakwater at Wicks Bay, Scotland, and pushed aside a fused mass of stone, concrete, and iron weighing twenty-six-hundred tons.

Surf once swatted away a bell attached (via 4-inch-thick metal brackets) 100 feet above-ground on a lighthouse in the Isles of Scilly, off the southwest tip of Cornwall. At the Tillamook Rock lighthouse in Oregon, waves from a December storm flung a boulder over the light itself, 139 feet above sea level. The rock landed on the lightkeeper's house, breaking a 20-foot-square hole in the roof and all but destroying the interior.

Fortunately for seaside dwellers, big surf tends to build up mounds of offshore sediment, creating a natural dampening system that keeps most heavy storms from chewing away the coast. An underwater process called "velocity skewness" forms sandbars where waves break. The bigger the swell, the farther off shore the sandbars emerge. These temporary shallows cause subsequent swells to expend most of their energy at sea, rather than unleashing it all on the puny human artifacts on shore.

SHORE ACRES STATE PARK, CAPE ARAGO, OREGON

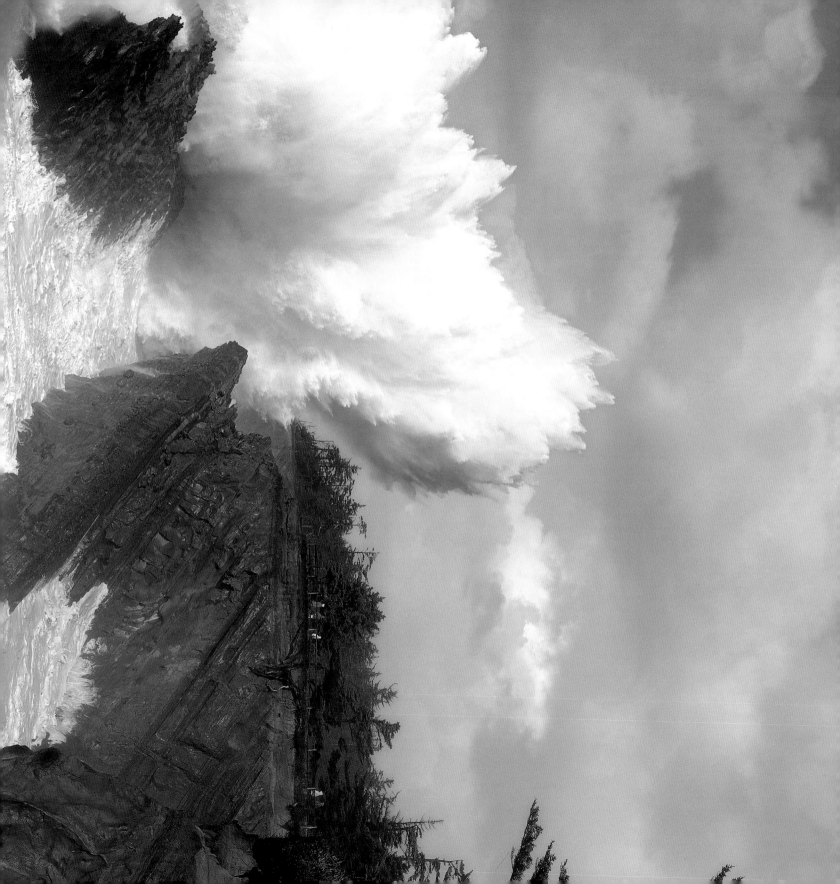

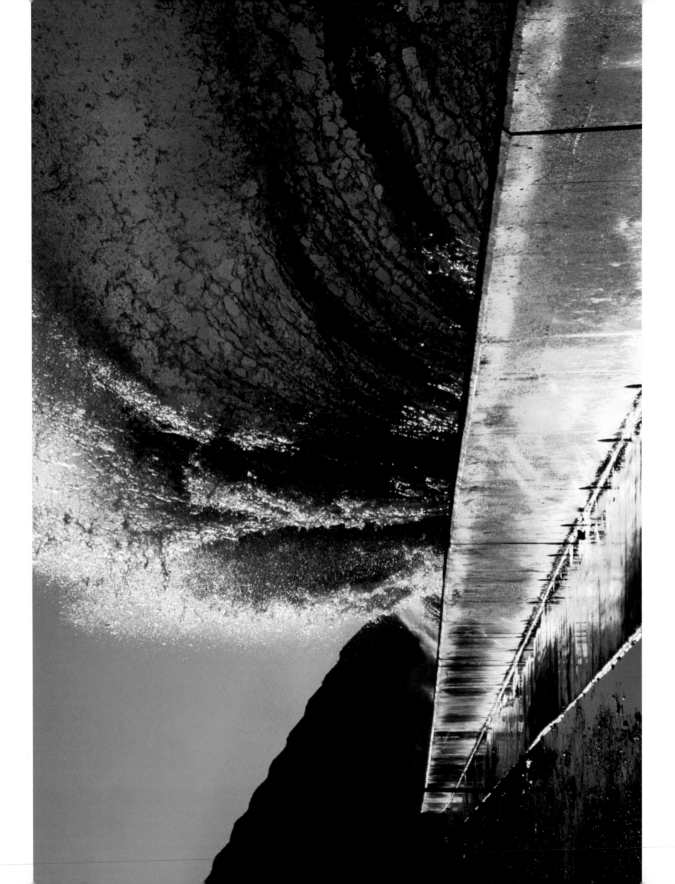

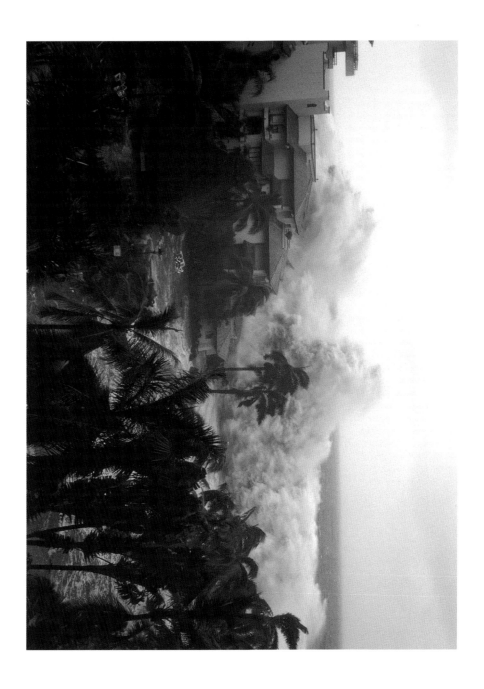

ABOVE **PUERTO ESCONDIDO, MEXICO**

LEFT **VENTURA COUNTY, CALIFORNIA**

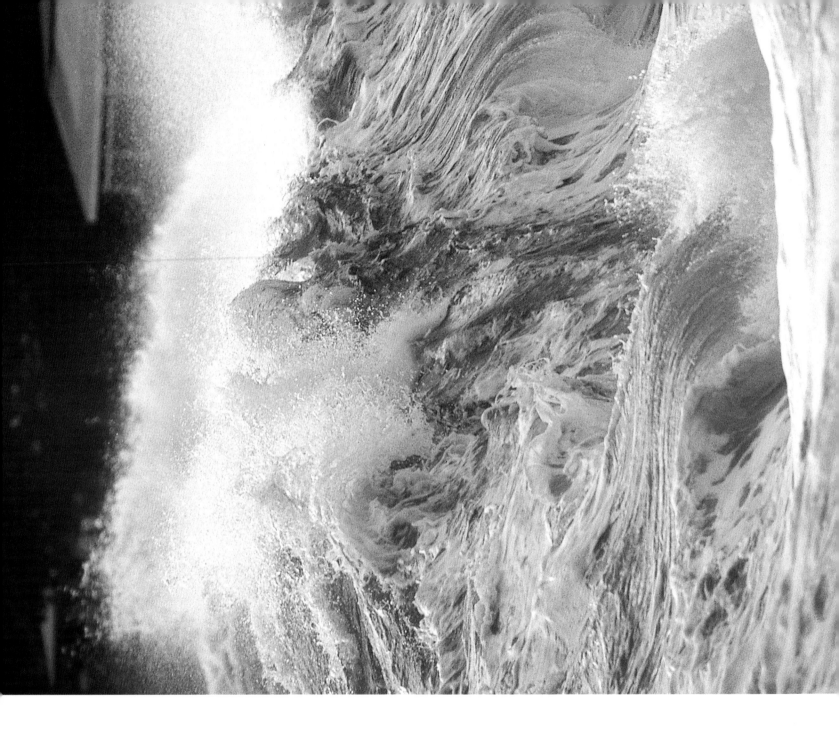

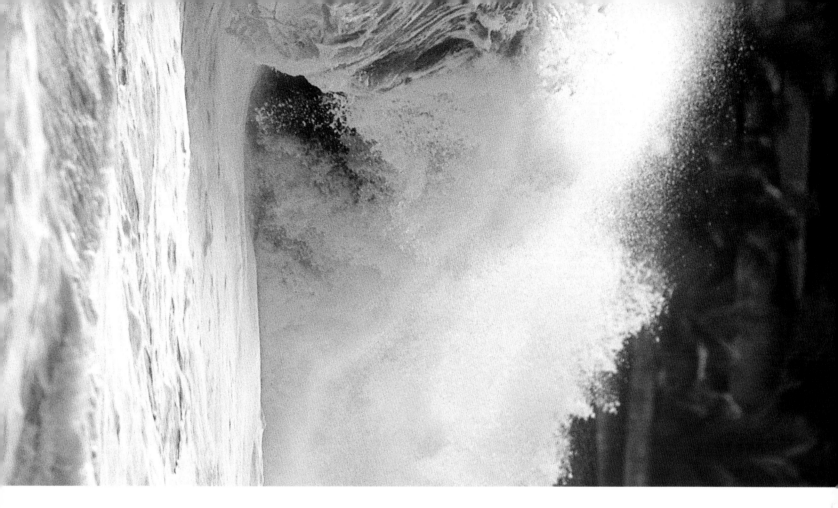

PAPARA, TAHITI

Surfers have as many names for the hollow, furling part of a wave as gangsters have for guns. Word choice helps carbon-date the speaker. "Tube" is the most common term, spanning all ages and regions. If, however, a surfer talks about riding inside the "curl," his passion for waves dates to the fifties or early sixties. Someone who describes the hollow as the "green room" or "crystal cathedral" most likely came of age in the era of paisley-painted surfboards and LSD. If he brags about riding in the "shack," "pit," or "hole," he is probably young and—in his own mind, at least—hip.

Surfers crave tubes, rare gems requiring a magical confluence of swell, bottom contour, wind, and tide. If a surfer manages to get inside one, the sensation is profound. He is surrounded on five of six sides by arcing water, yet still dry, all while rushing headlong toward a moving, teardrop-shape portal of sky at the end of the spinning pipe.

VENTURA COUNTY, CALIFORNIA

FOLLOWING PAGES, LEFT **HOLLOW TREES, MENTAWAI ISLANDS, INDONESIA**
FOLLOWING PAGES, RIGHT **VENTURA COUNTY, CALIFORNIA**

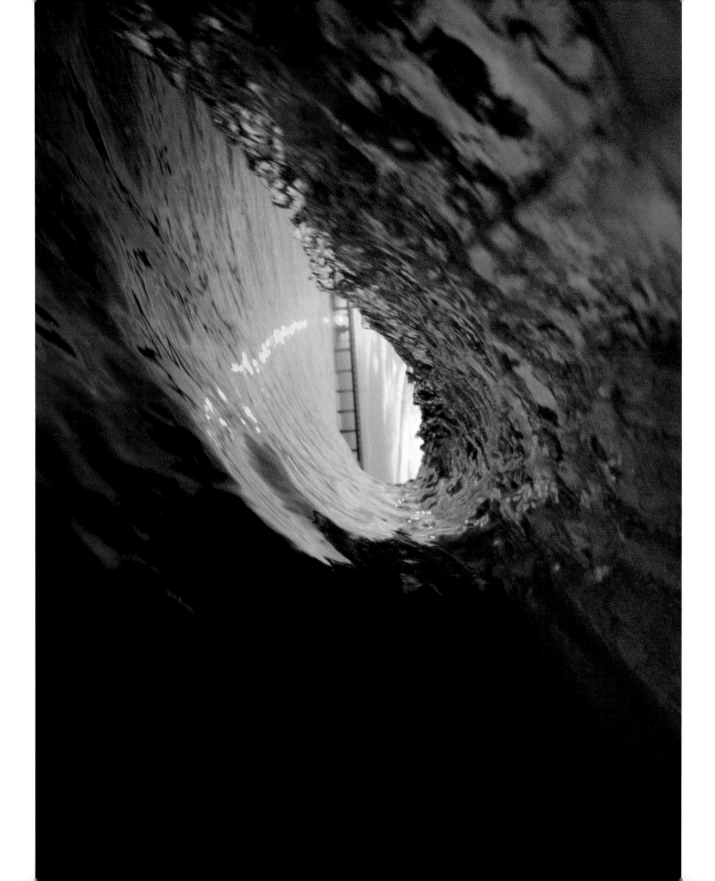

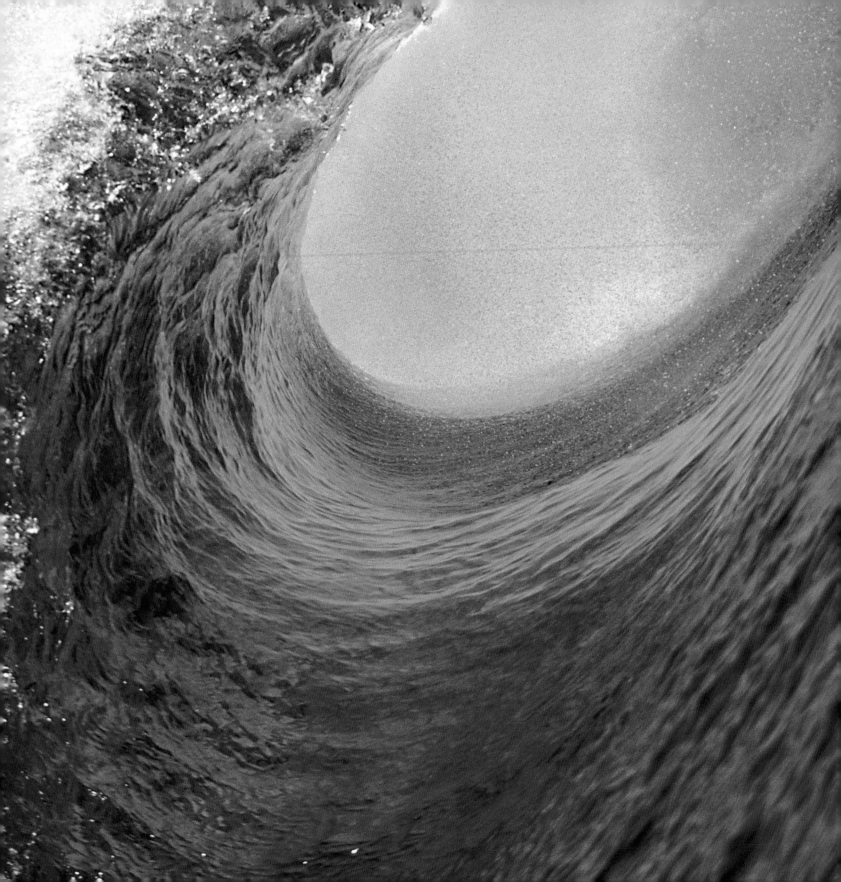

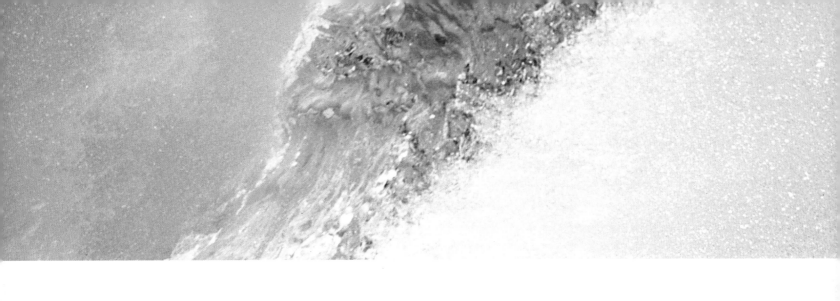
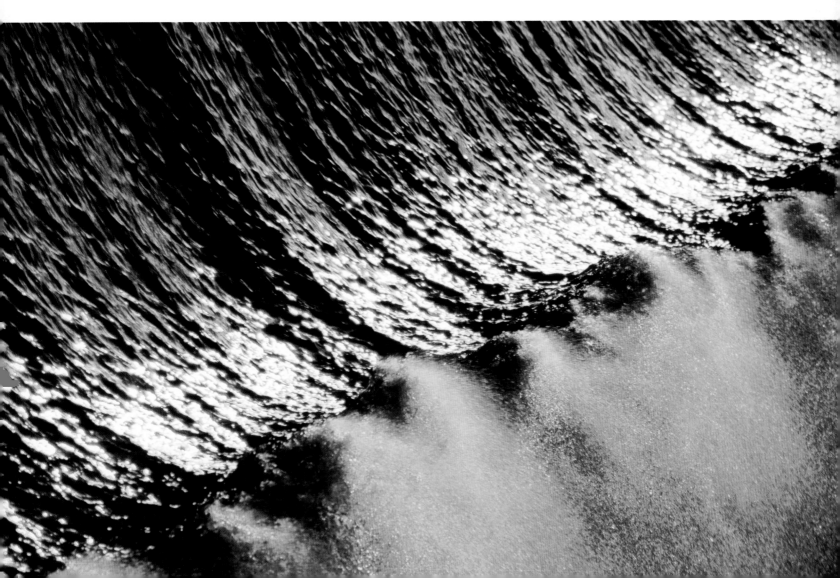

LONGNOOK BEACH, CAPE COD, MASSACHUSETTS

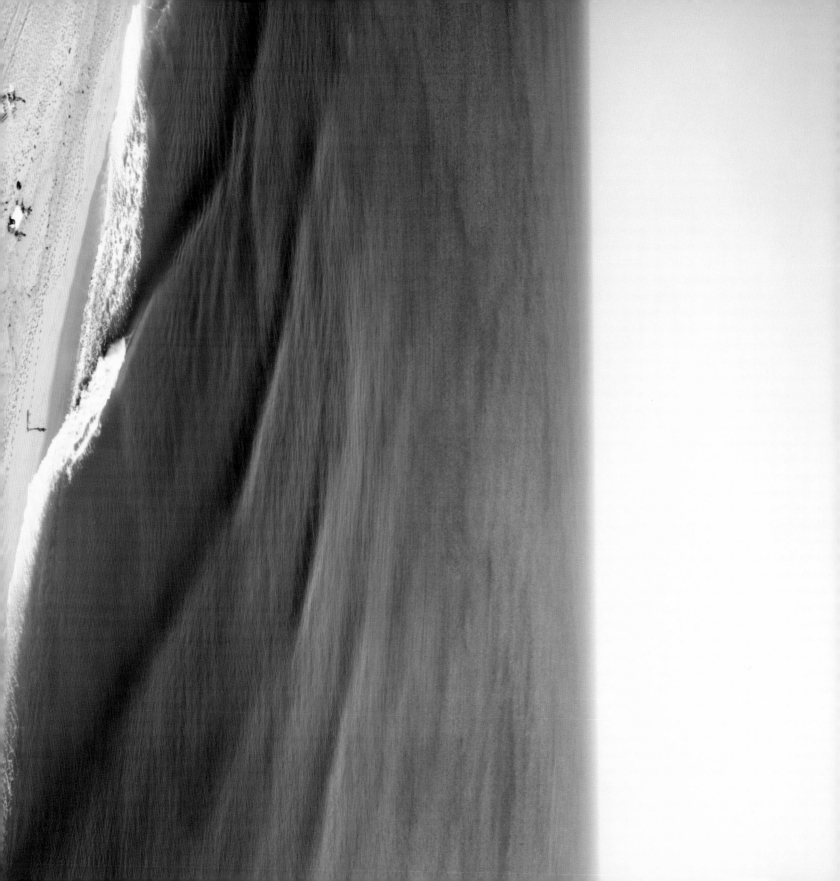

Tidal waves, more accurately known as tsunamis, resemble wind waves only in that they are invisible swells of energy that move through the ocean. If you blow across a long pan of water you can create your own little wind waves; rock the same pan back and forth, and you'll have an idea of how tsunamis work. A wind wave is a kitten: cute, and fun to have around the house. A tsunami is a mountain lion.

Tsunamis erupt from a single tumult: an earthquake, a volcano, a submarine rockslide, even an extraterrestrial object splashing into the sea. They are more like transoceanic sloshes than wind-blown waves, and they are very rare.

Even the biggest and most powerful wind-generated swell will move at a maximum speed of about thirty-five miles per hour. A tsunami can rush through the water at up to five hundred miles per hour, with the weight of the ocean behind it. Which is why a three-foot-high tsunami can raze a low-lying beachfront town, slamming boats into buildings and sucking villagers out to sea.

The Hawaiian Islands sit at the heart of the world's most potent tsunami zone, with seis-mically active coasts to the west, east, and north. In Hawaii, tsunamis have killed more people than earthquakes, volcanoes, and hurricanes combined. On the morning of April 1, 1946, a 7.3 earthquake in the Aleutian Islands spawned a wave that poured onto Hawaii only five hours later. The photos on the facing page show the wave surging over a seawall near the city of Hilo. It penetrated up to half a mile inland and killed 159 Islanders.

76

HILO, HAWAII, 1946

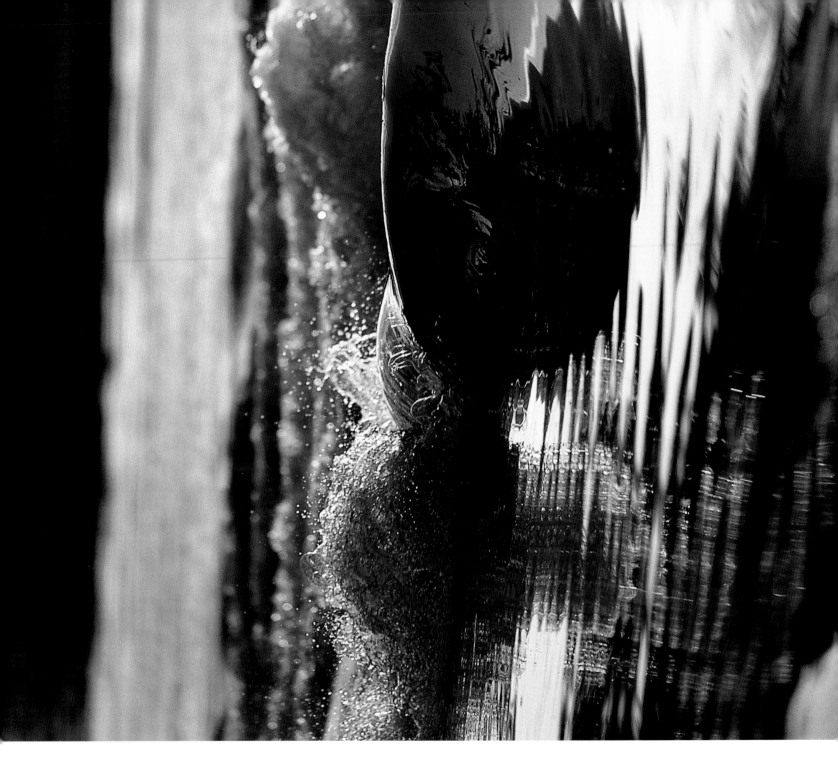

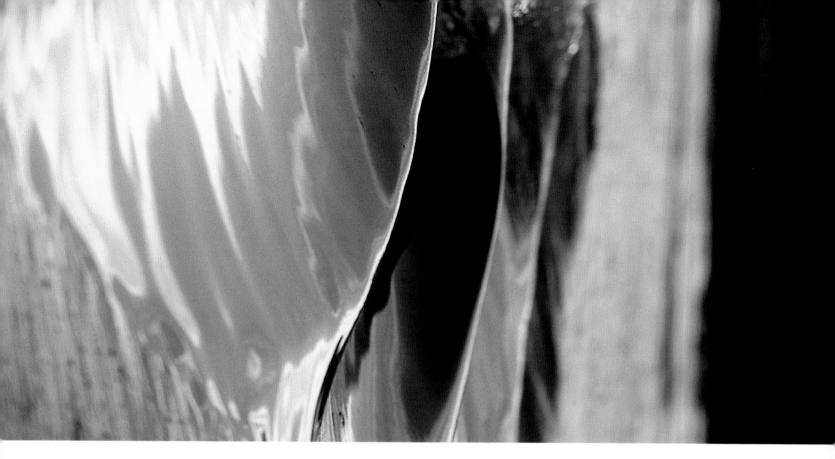

BOAT WAKE, PAPARA, TAHITI

BELOW **NORTH NARRABEEN, NEW SOUTH WALES, AUSTRALIA** RIGHT **AVALON POINT, NEW SOUTH WALES, AUSTRALIA**

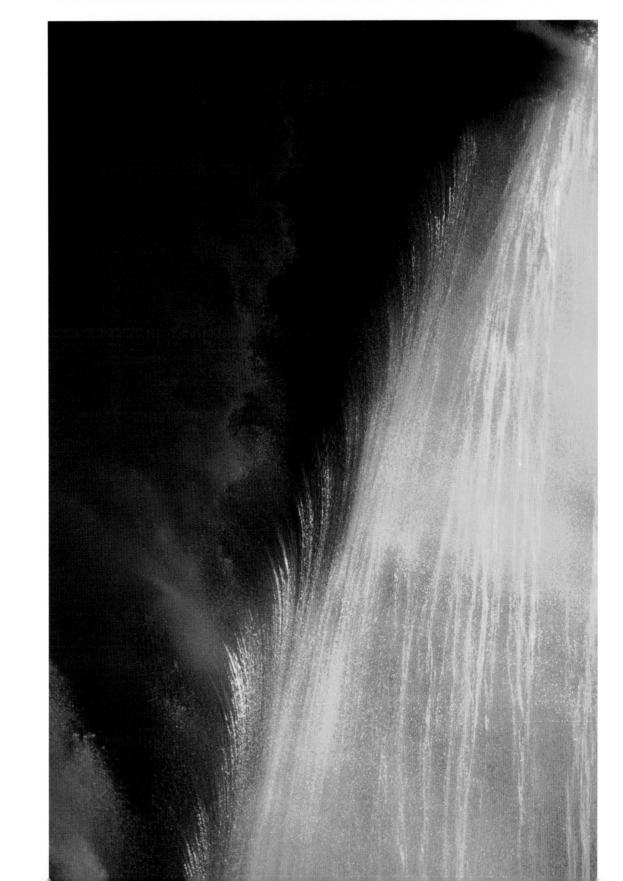

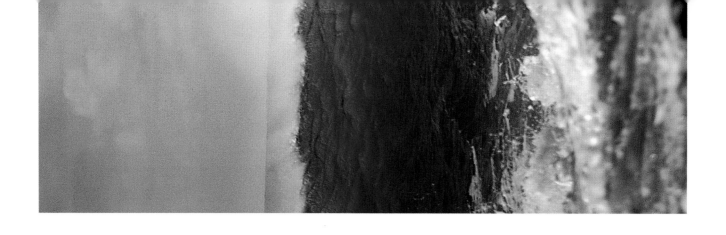

WEST OAHU, HAWAII

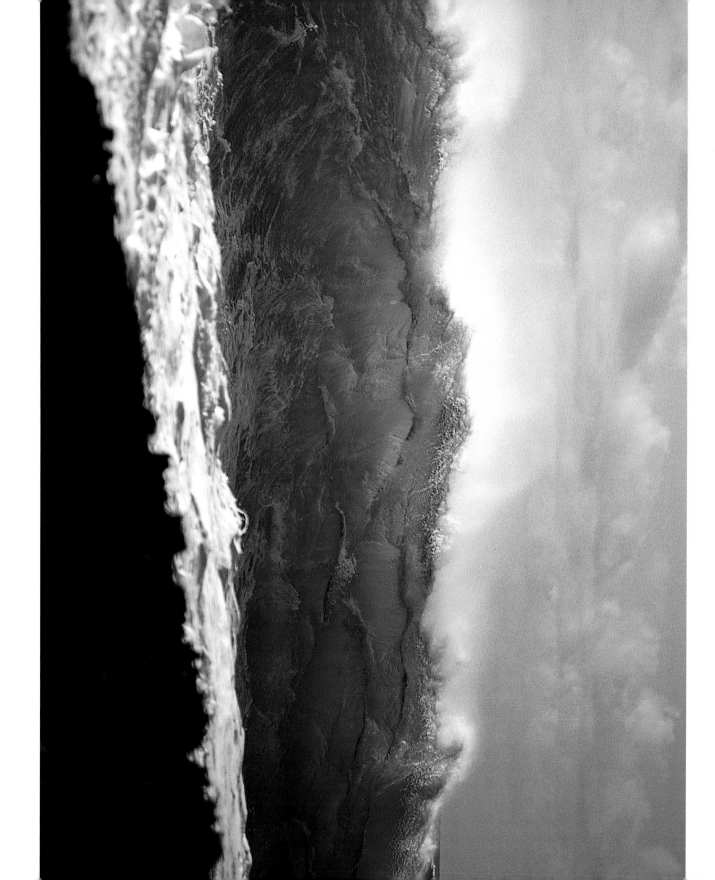

Every inch of ocean shore has waves, and most of it has been examined by surfers: from Spitsbergen Island (above the Arctic Circle) in the north, to Lowe Island (off Antarctica) in the south. Surfers have ridden fun waves in Oman, Myanmar, and the Aleutian Islands. Ireland has beautiful surf, as do Tasmania, Easter Island, and Madagascar. Thriving surf scenes exist in Wisconsin, in Israel, and on Vancouver Island. There are surf shops in Sri Lanka and surf camps in New Guinea.

In one of mankind's most extraordinary encounters with waves, however, surfing was the last thing on anyone's mind. During his failed but heroic 1914–16 expedition to Antarctica, Sir Ernest Shackleton and his twenty-seven crewmen were stranded for sixteen months when their ship became trapped in ice. When they finally drifted to the edge of the pack, they climbed into three small dories and sailed for open sea. But a gale quickly blew up, and the ice began to squeeze in once again. Just before dark, they hauled their boats onto an iceberg and tried to get some sleep. The next morning, they awoke to a horrifying but exhilarating sight.

Overnight, the wind had driven toward them a sea of broken ice—thousands of bizarrely shaped berg bits and floes, stretching to the horizon, all rising and falling steadily on a thirty-foot groundswell. "The whole scene had a kind of terrifying fascination," Alfred Lansing wrote in his gripping 1959 account, *Endurance: Shackleton's Incredible Voyage.* "The men stood by, tense and altogether aware that in the next instant they might be flung into the sea to be crushed or drowned, or to flounder in the icy water until the spark of life was chilled from their bodies. And yet the grandeur of the spectacle before them was undeniable."

EASTER ISLAND

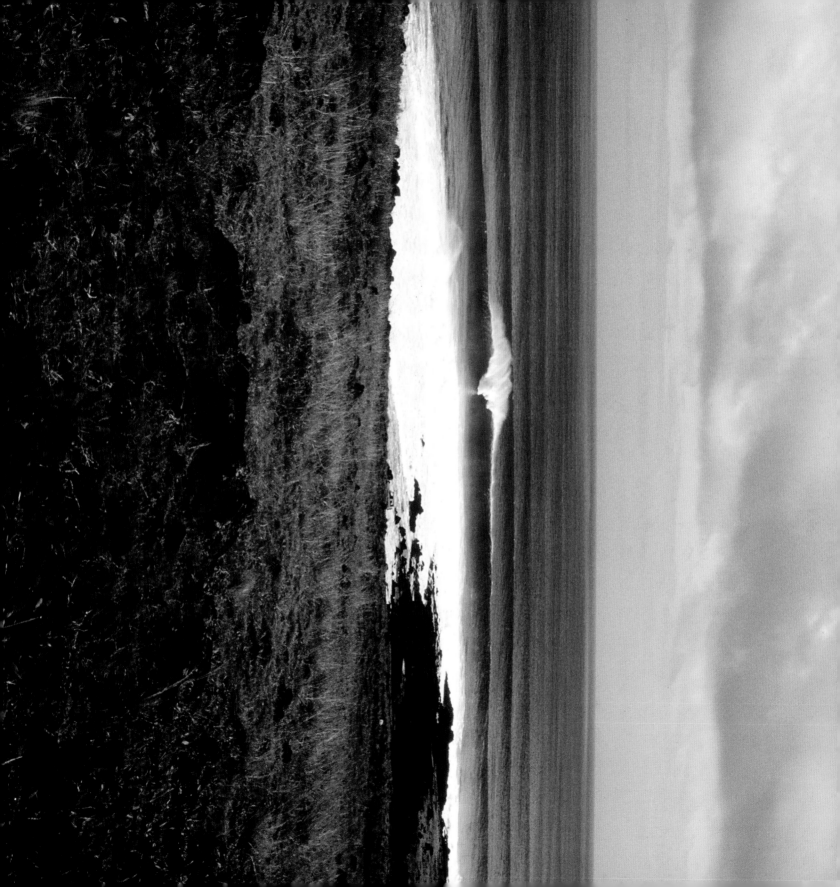

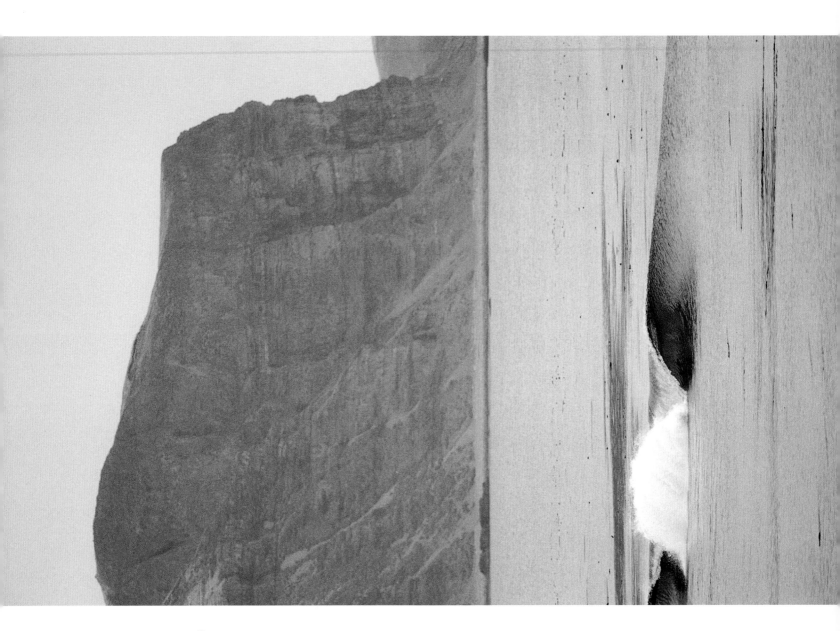

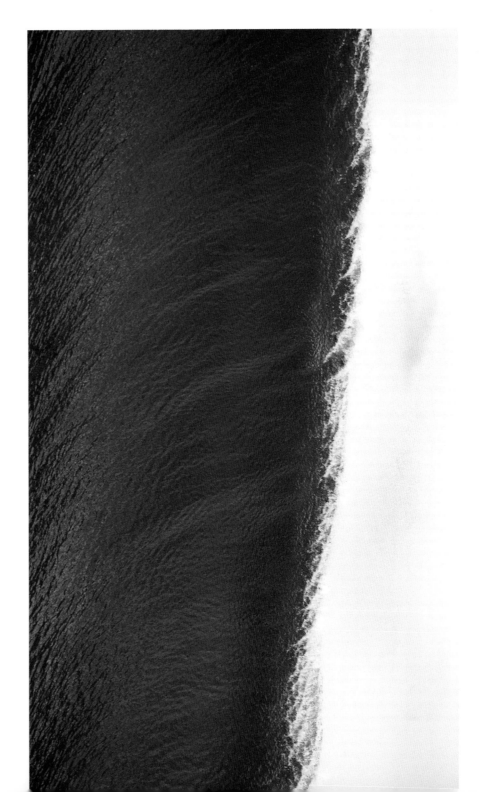

ABOVE **HOLLOW TREES, MENTAWAI ISLANDS, INDONESIA**

LEFT **UMNAK ISLAND, ALEUTIAN ISLANDS, ALASKA**

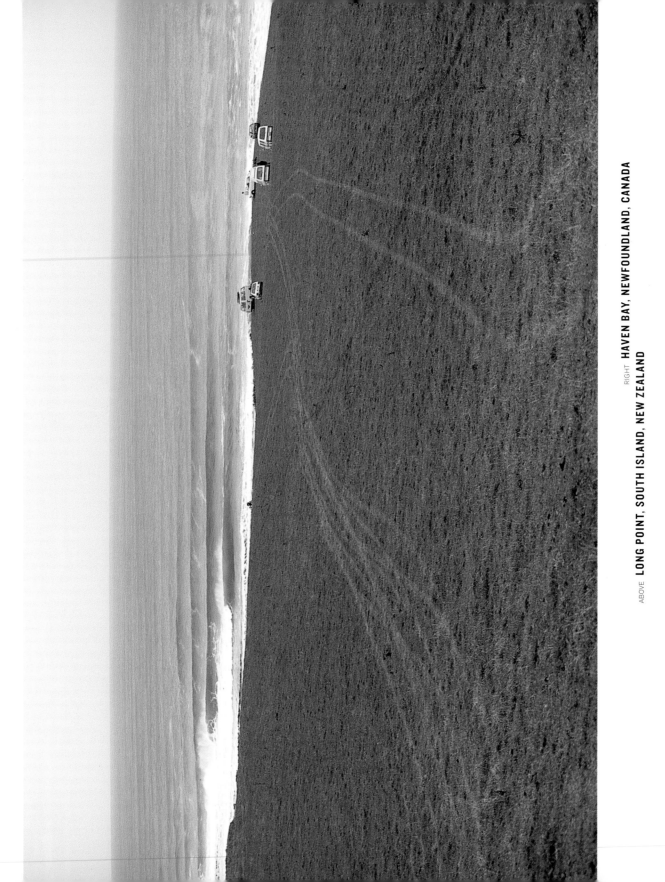

ABOVE **LONG POINT, SOUTH ISLAND, NEW ZEALAND**

RIGHT **HAVEN BAY, NEWFOUNDLAND, CANADA**

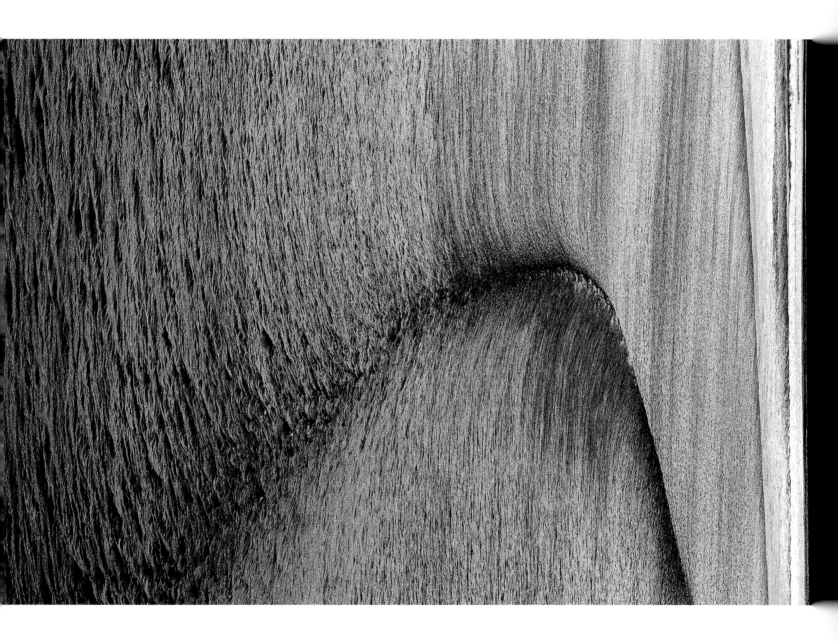

For decades, oceanographers depended upon seamen to tell them how big waves could get. In the early 1900s they erroneously concluded that an open-ocean wave could never grow beyond 60 feet without breaking. But computer models have since shown that strong storms could, under the right circumstances, produce waves exceeding 200 feet.

The biggest open-ocean wave ever observed is believed to be a 112-footer measured by a watch officer on the bridge of the USS *Ramapo*, a 478-foot Navy tanker, in February 1933. The ship, which was traveling from the Philippines to California, encountered swell generated by a typhoon fetch thousands of miles long. The biggest wave ever measured by instrument was an 86-footer logged by a British weather-data ship in the North Atlantic in December 1972.

As they enter shallow water near shore, waves decelerate, crowd together, and surge in height. In recent years, surfers assisted by jet-powered watercraft have been towed into breaking waves (at places like Maverick's in Northern California, Jaws on Maui, and Cortes Bank, a seamount one hundred miles off the coast of Southern California) with faces reliably measured in the 60- to 70-foot range. Such swells are too big and fast to paddle into, so the surfers use personal watercraft and water skiing ropes to tow each other into the waves.

In November 2001, one of the biggest waves ever captured on film swept across the reef at Maverick's during a massive northwest swell marred by rain, south winds, and choppy seas. Longtime big-wave surfers Grant Washburn and Jeff Clark videotaped the mammoth swell as it broke in deep water a good quarter mile beyond the spot's traditional takeoff zone. Because the grainy, Zapruder-style footage lacks any reference marker (a boat, say, or a surfer), no one has precisely measured the wave's size. But the surf media has since inked the day into the sport's history book as "One-Hundred-Foot Wednesday."

MAVERICK'S, HALF MOON BAY, CALIFORNIA

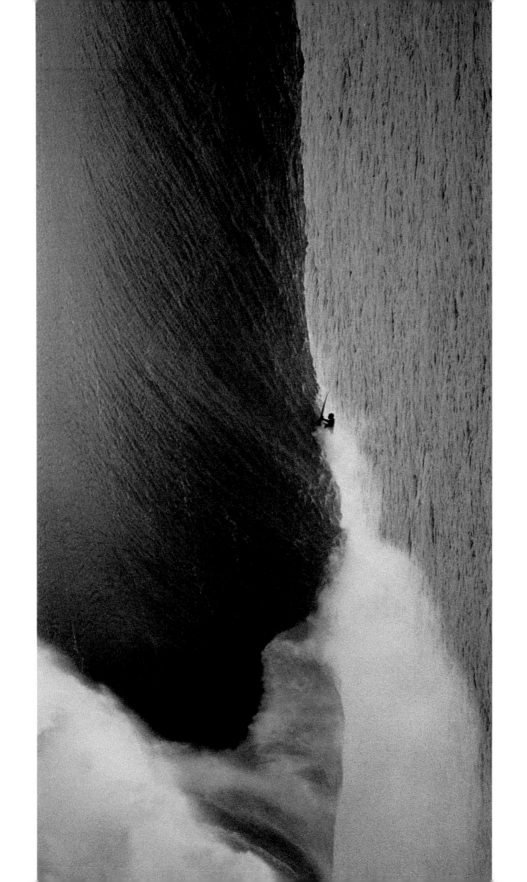

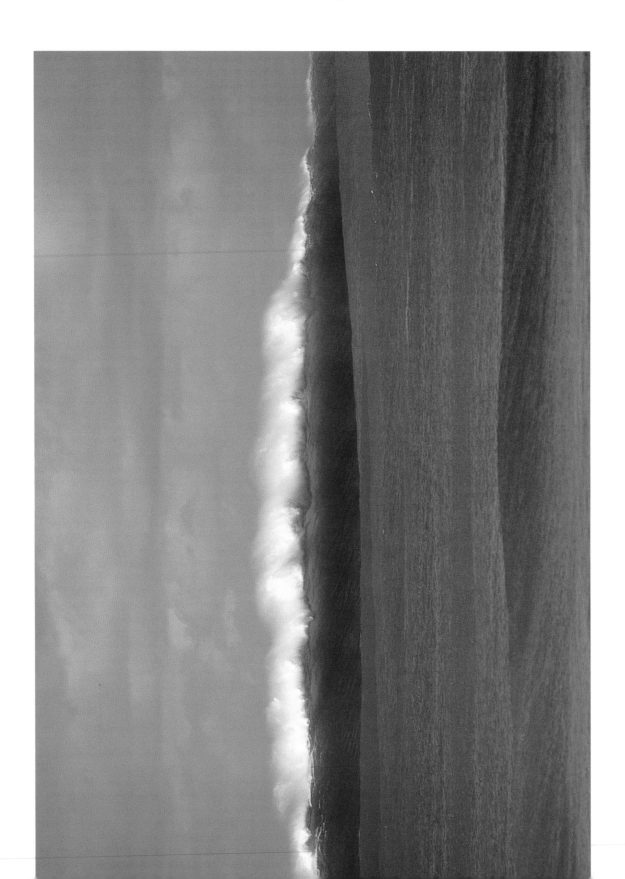

KAENA POINT, OAHU, HAWAII

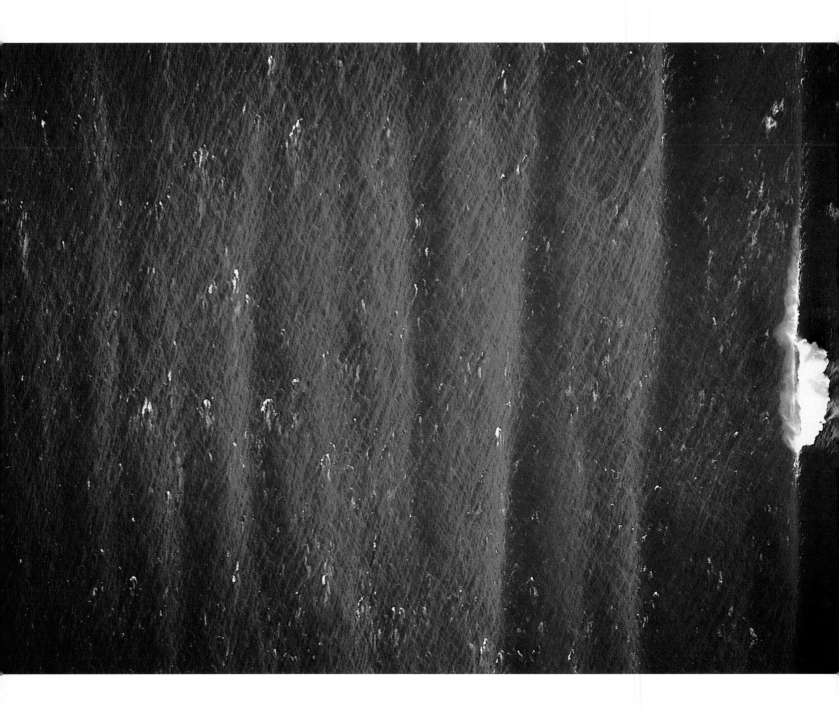

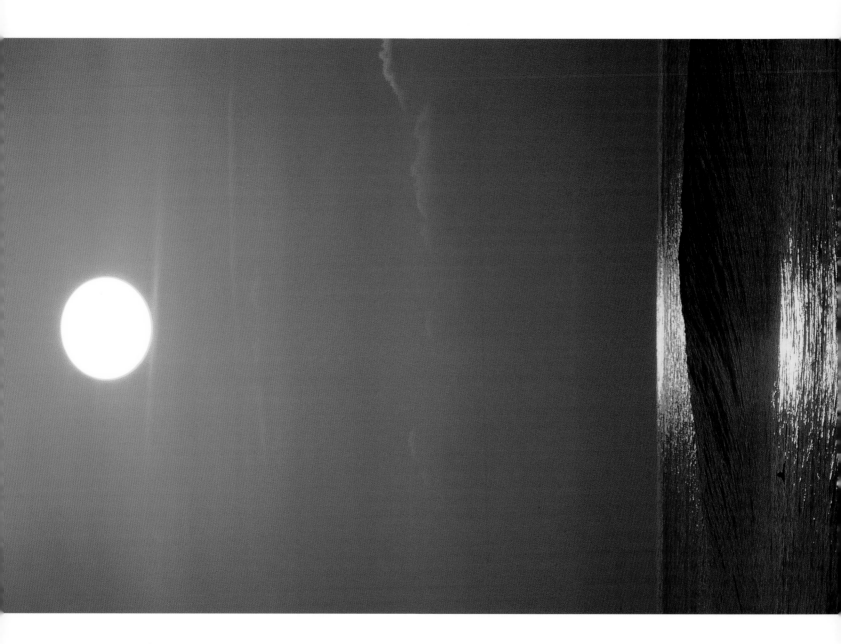

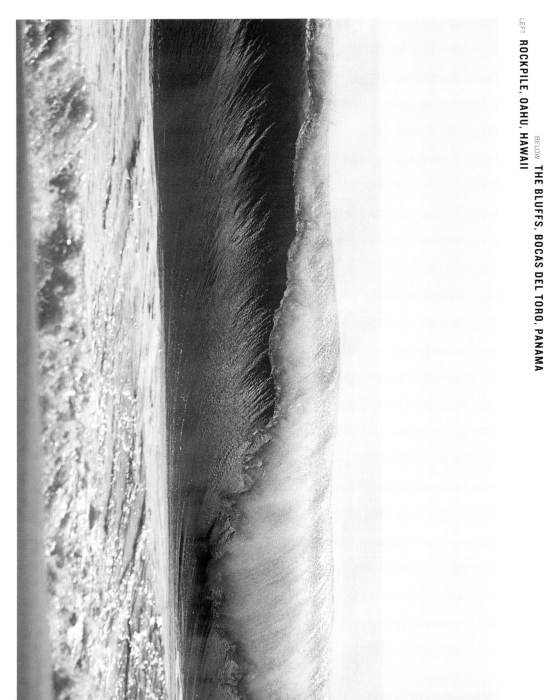

BELOW **THE BLUFFS, BOCAS DEL TORO, PANAMA**

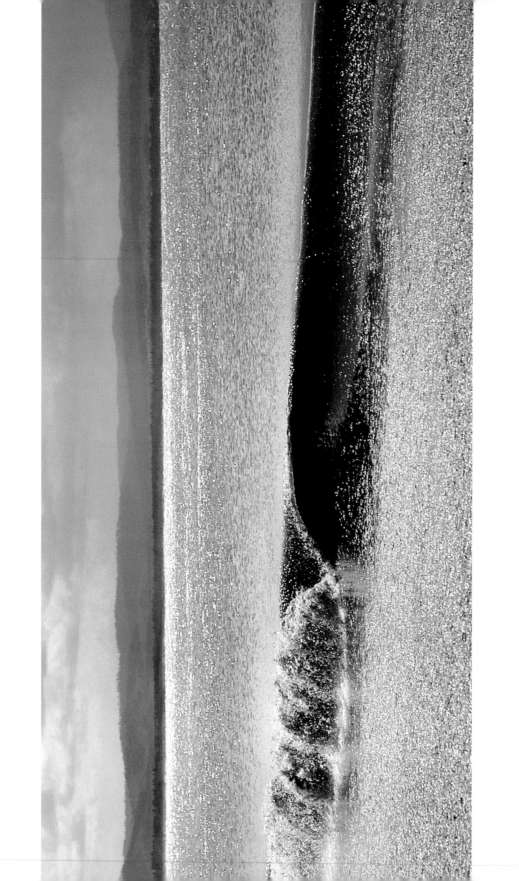

ABOVE **SEVEN MILE BEACH, TASMANIA, AUSTRALIA**

RIGHT **JEFFREYS BAY, SOUTH AFRICA**

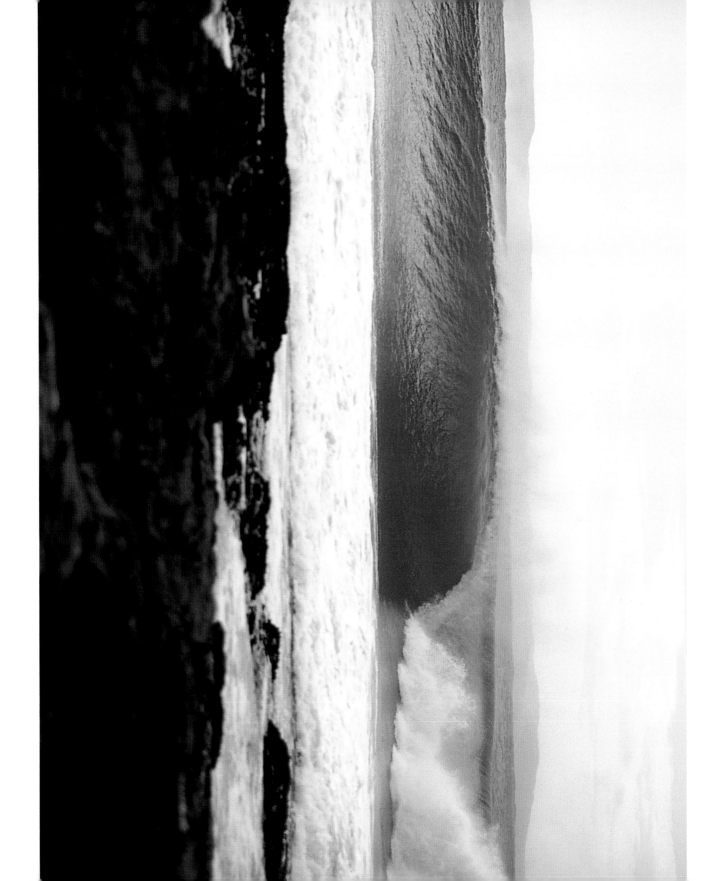

Most people avoid opening their eyes underwater to see what a breaking wave looks like from beneath. Saltwater stings, and divers with face masks prefer to float beyond the surf zone.

Their loss.

The view from below reveals a dream world of moving water, distorted sky, and bubble bursts. When a powerful wave pitches out, the lip lands in the forward trough and detonates, often encasing a cylindrical pocket of air that appears to be flummoxed about which way is up. Even as the broken wave rumbles toward shore, its effects linger in the impact zone. Whirlpools continue to boil, and the surfacing fizz hisses and steams like freshly poured champagne.

ABOVE **HONAUNAU BAY, BIG ISLAND, HAWAII**
RIGHT **WAIMEA BAY, OAHU, HAWAII**

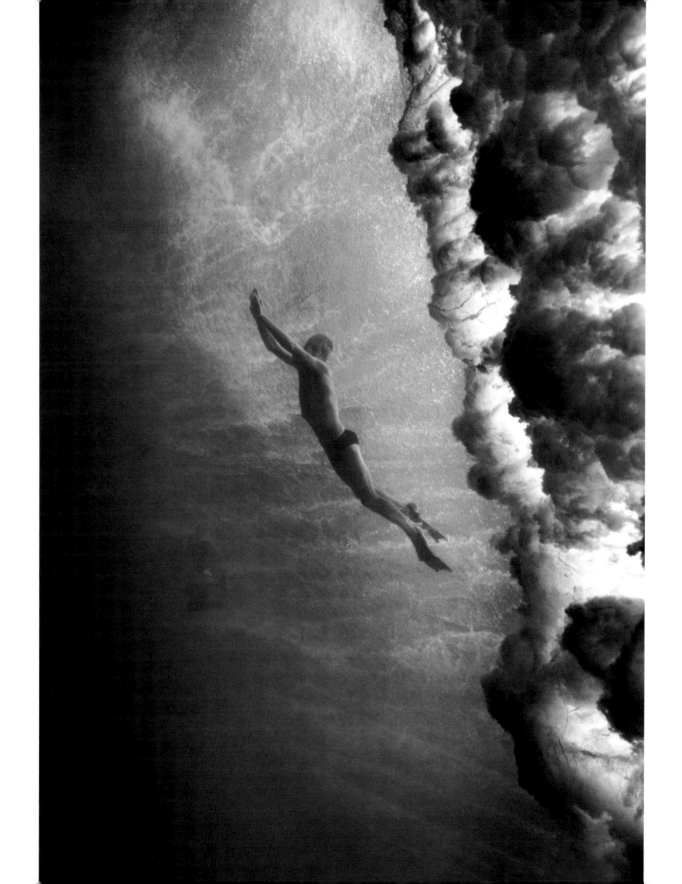

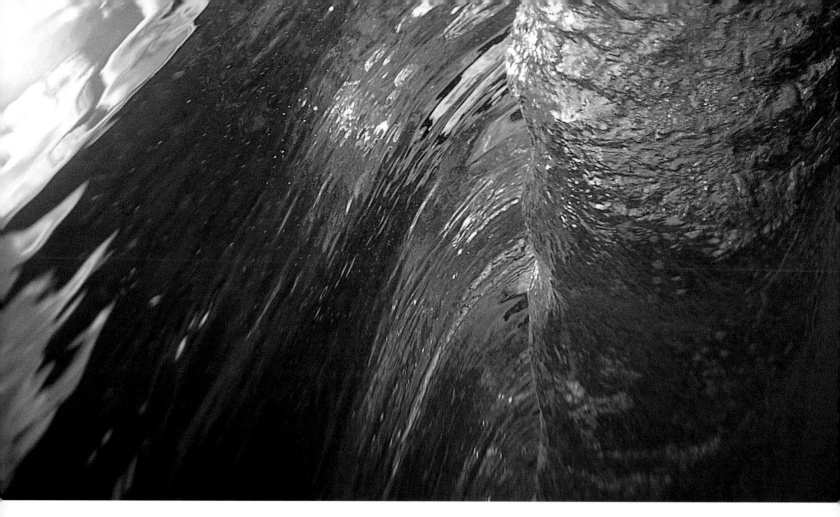

KEIKI BEACH, OAHU, HAWAII

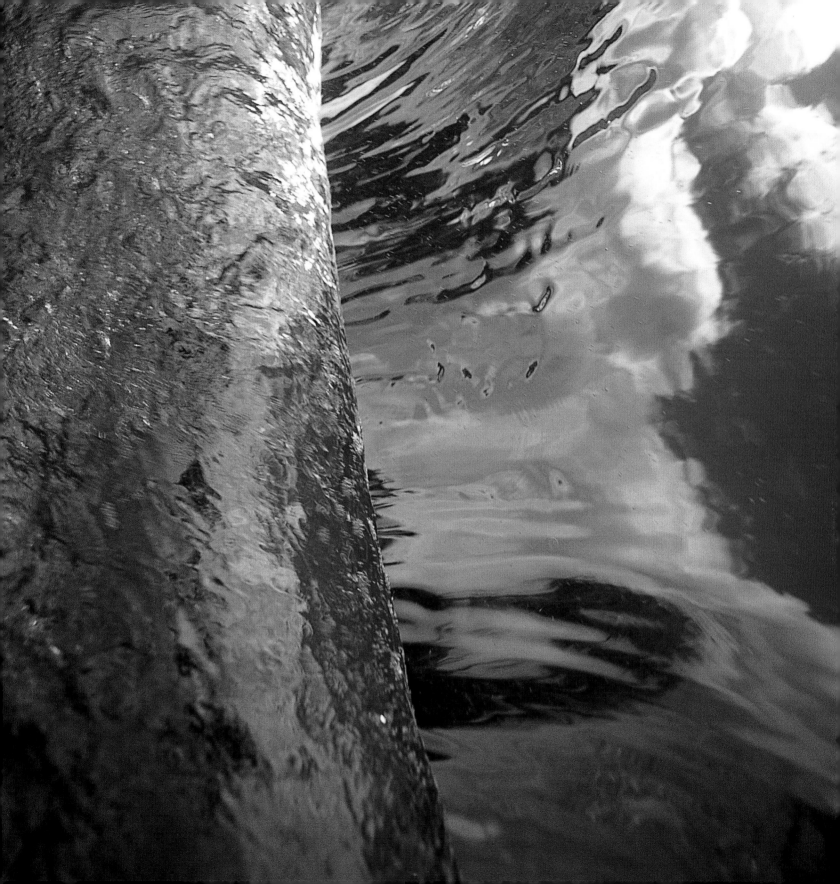

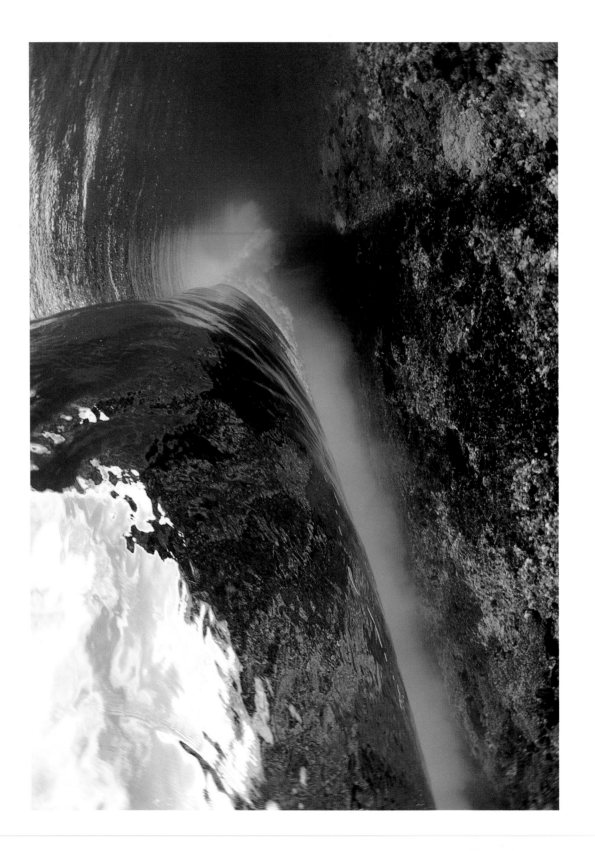

LEFT **CLOUDBREAK, TAVARUA, FIJI**

BELOW **BALI, INDONESIA**

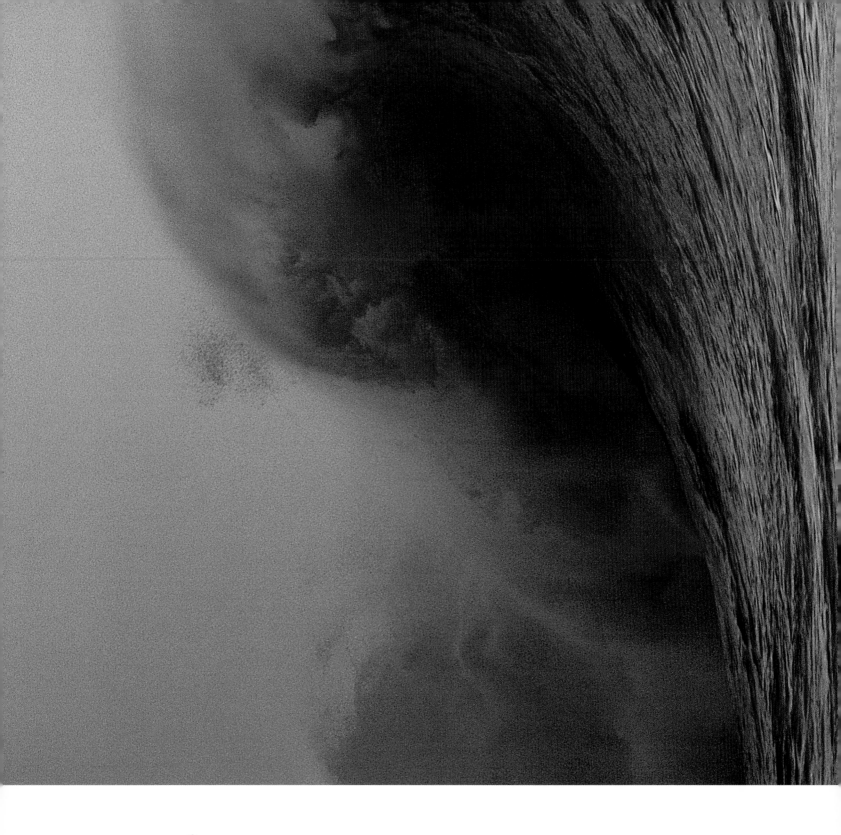

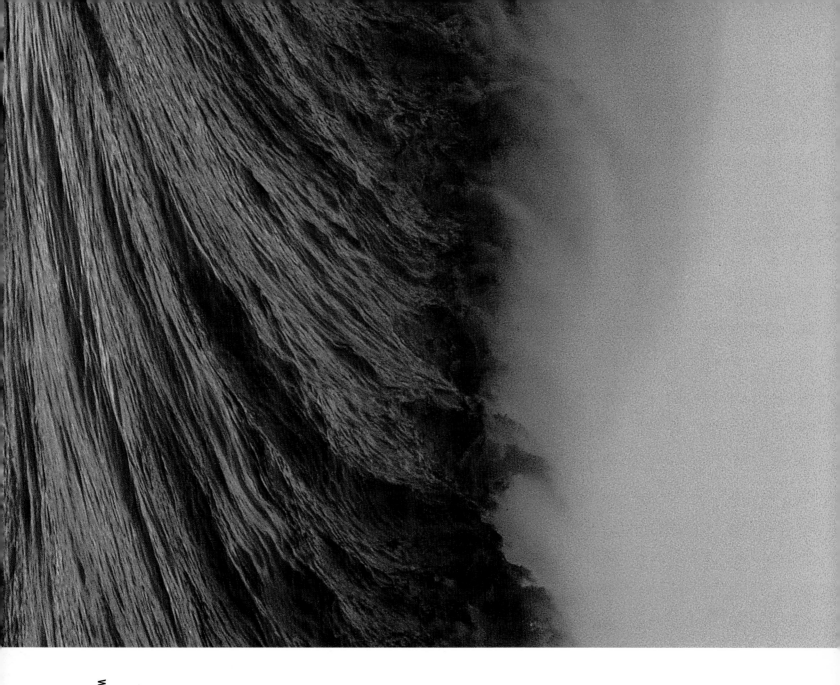

WAIMEA BAY, OAHU, HAWAII

Too often, surfers lapse into anthropocentric idiocy when they encounter good surf, as if a cleanly peeling wave had been designed with their pleasure in mind. This kind of thinking, of course, is why humans continue to muck up the planet: we believe it was made for us.

And yet sometimes it seems that wave riding does have a place in the natural order. Pelicans airsurf a few inches above breaking waves, using the ever-shifting updraft to fuel their down-coast commute. Seals bodysurf with a style and velocity that men wearing Speedos and fins only dream about. Dolphins torpedo through the curl in the exact position that surfers seek, launching into the air as the waves close out.

There's no Darwinian explanation for such goofiness. Time spent riding waves is time spent away from the things a person or a sea lion needs to do to survive: making money, raising babies, catching fish.

Or maybe Darwin *could* explain it. As animals move up the evolutionary ladder, they get smarter. As they get smarter, they get more efficient at feeding and protecting themselves and thus have more time to play. That's why ants never relax, and why dolphins make surfers look like dorks.

GAVIOTA, CALIFORNIA

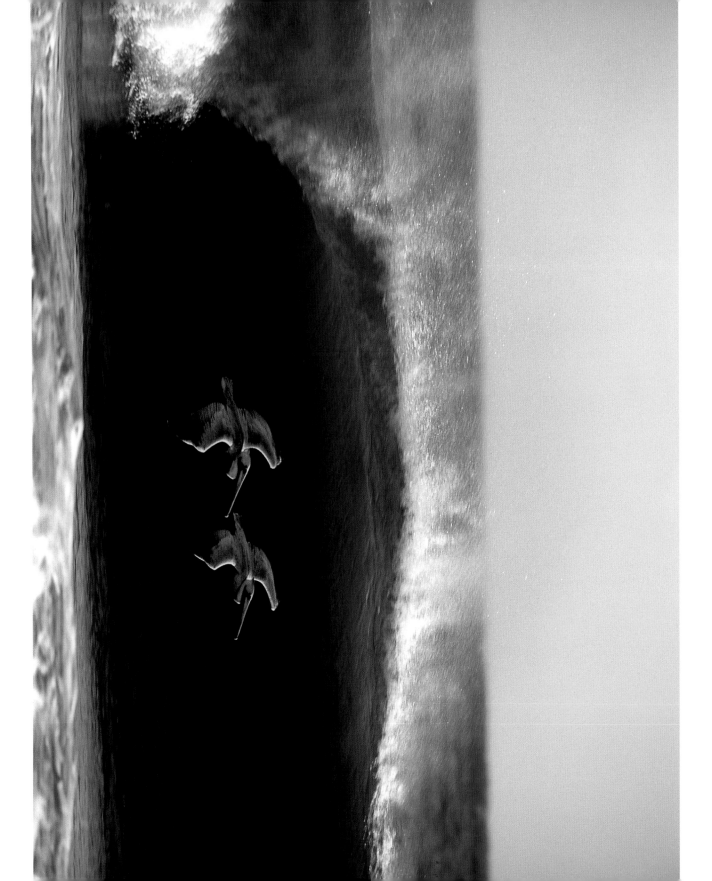

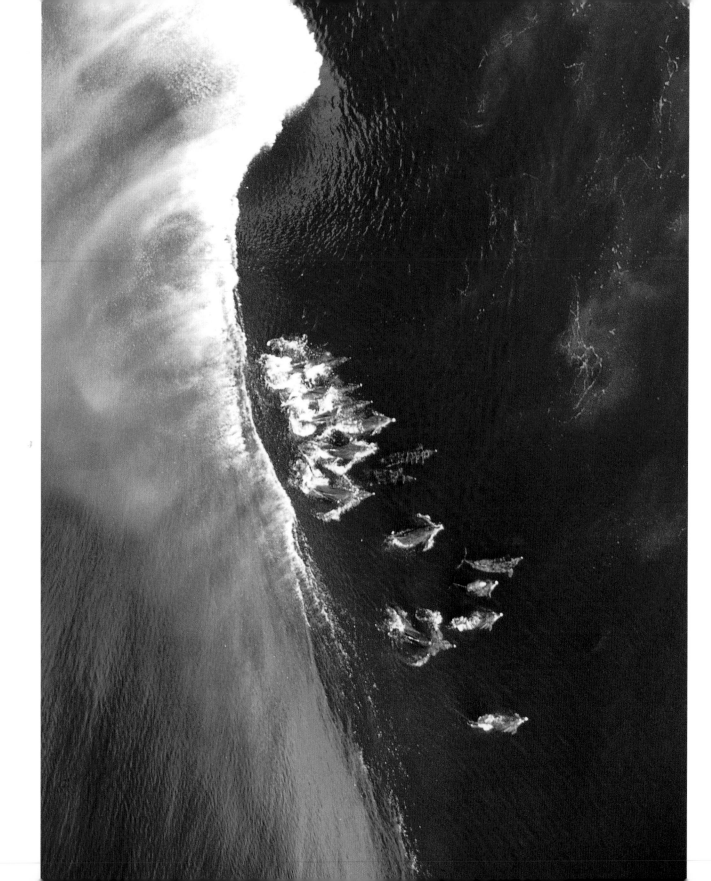

VENTURA COUNTY, CALIFORNIA

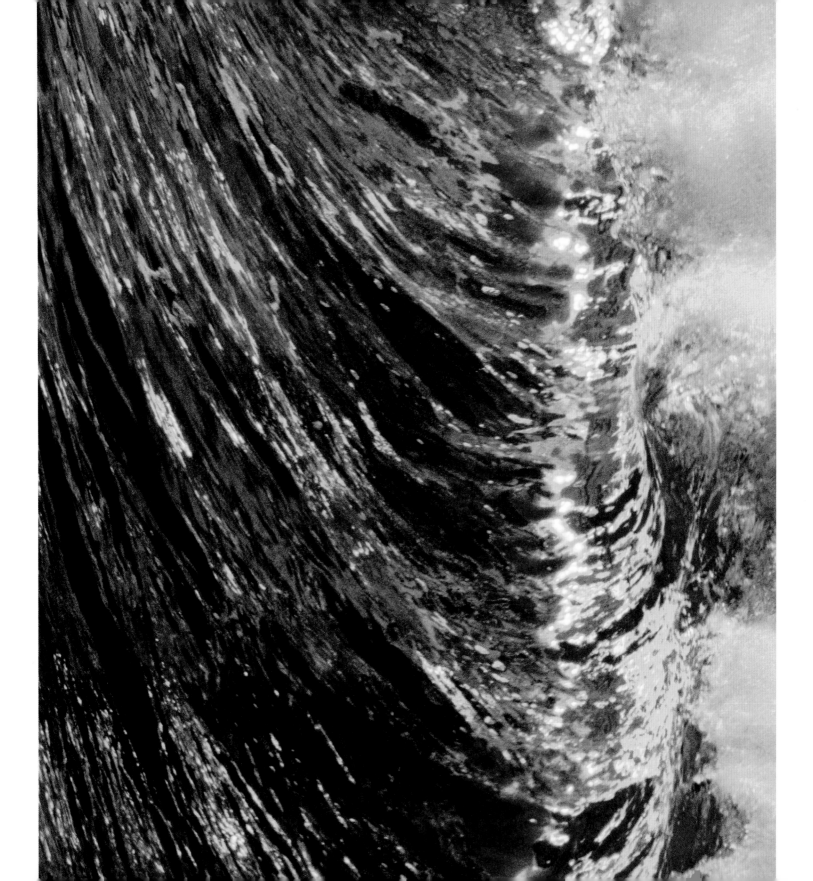

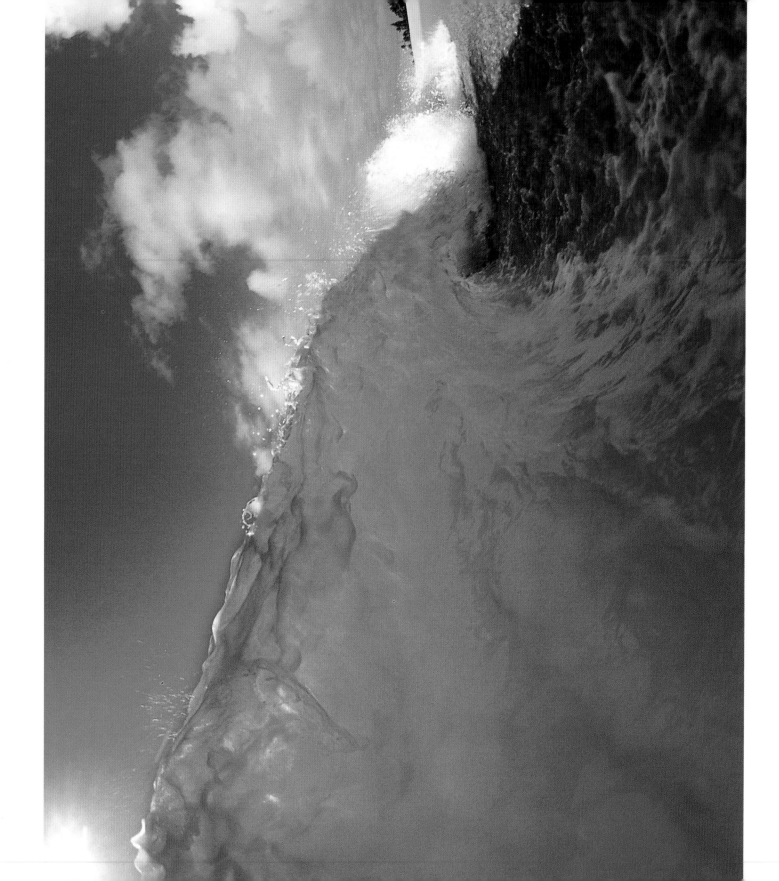

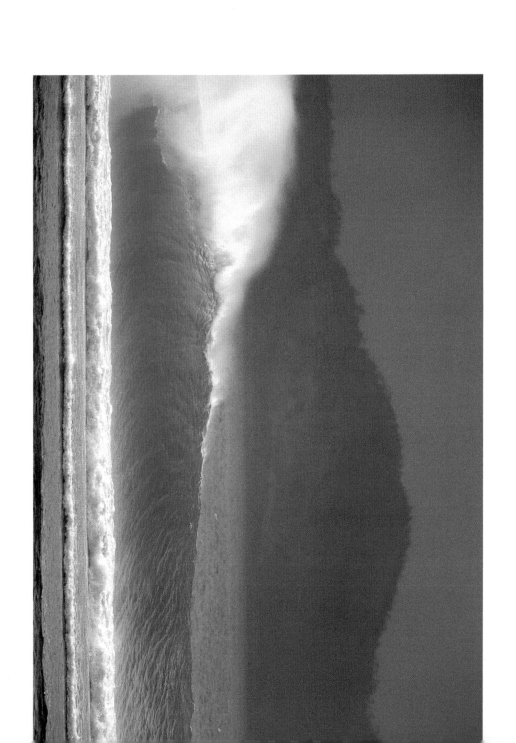

LEFT **OFF THE WALL, OAHU, HAWAII**

BELOW **RESTAURANTS, TAVARUA, FIJI**

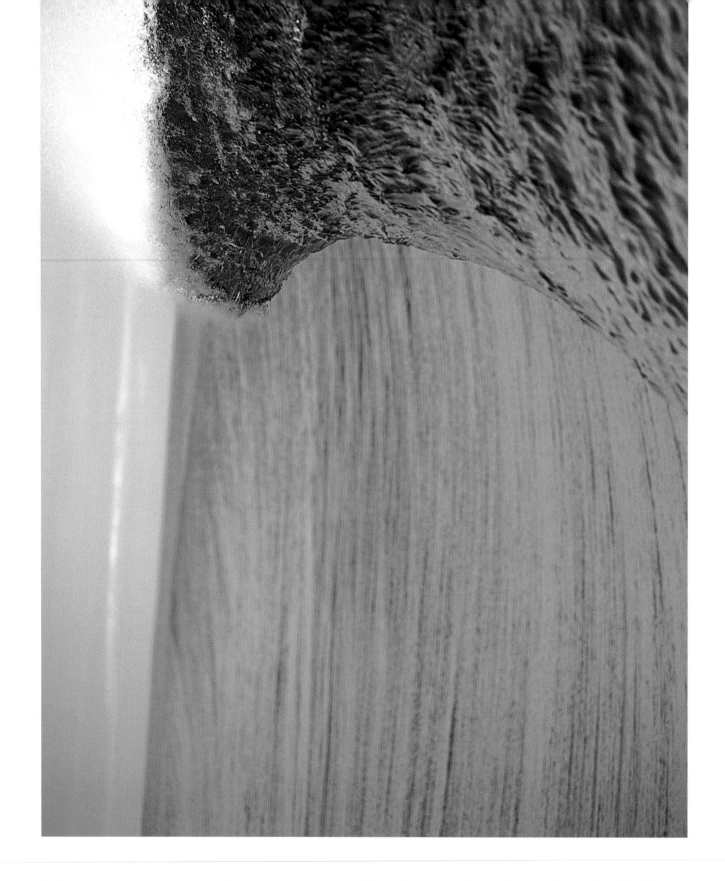

Teahupoo in Tahiti mesmerizes surfers because it is almost—but not quite—too shallow, too hollow, and too fast-breaking to ride. A quarter-mile out to sea, the wave lunges out of inky open ocean onto a frighteningly shallow barrier reef. As the wave stands up to break, it pulls water off the reef in front of it, transforming the shoreward trough into a boil-laden killing field.

On a five-foot day, Teahupoo can be thick and breathtaking but still forgiving enough that some surfers would describe it as "fun." Over eight feet, it is one of the world's most dangerous surf spots. A big wave looks more like a tidal surge than the product of a distant breeze. Many world-class surfers have suffered horrific wipeouts at Teahupoo—raked across the coral, held underwater for two consecutive waves. But serious injury and death (one, so far) are relatively rare.

TEAHUPOO, TAHITI

BILGOLA BEACH, NEW SOUTH WALES, AUSTRALIA

OFF THE WALL, OAHU, HAWAII

Good surf softens urban ugliness. Citified surfers can trot across the bustling coast high-way, turn their backs on the man-made madness, and dive directly into a wilderness that feels a thousand miles removed.

When a big swell lights up a metropolitan beach, residents of all sorts gravitate to the coast. Commuters pull over at the first available seaside parking spot to watch the show, like bus-bound tourists at an African wildlife refuge.

At San Francisco's Ocean Beach, the juxtaposition is profound. One of the world's best sand-bottom breaks, Ocean Beach routinely serves up clean but forbidding twenty-foot peaks during the prime winter season. The water is cold, and the persistent, powerful lines of white water often beat challengers back to the sand before they can paddle out far enough to catch a single wave. Many surfers have come close to drowning at Ocean Beach, and many have experienced transcendent moments—all directly across the street from a three-mile-long wall of scruffy row houses.

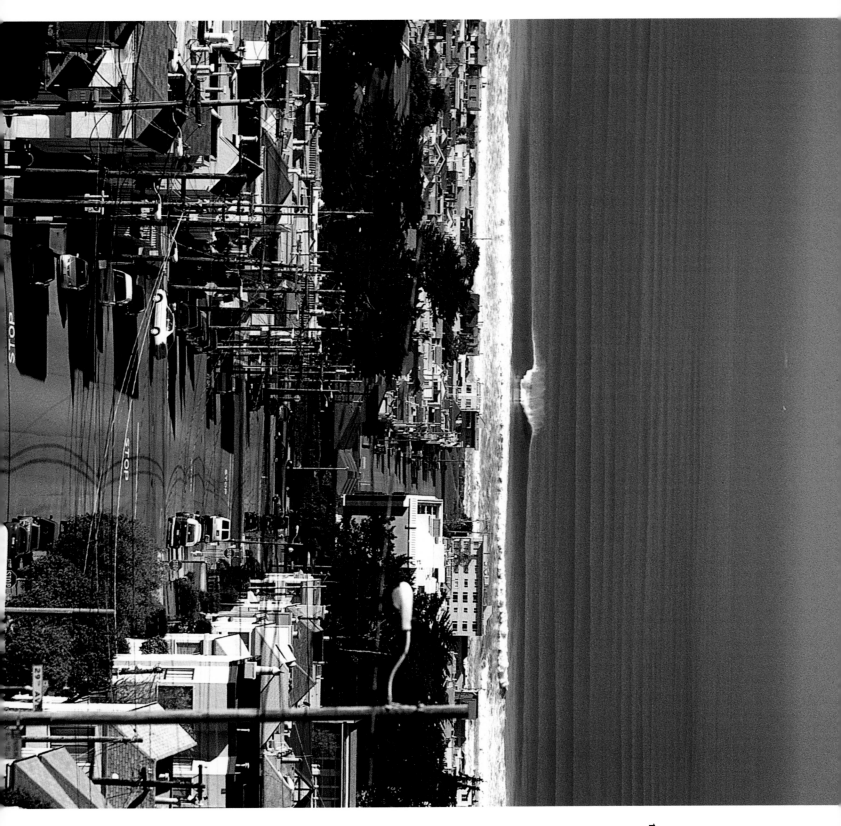

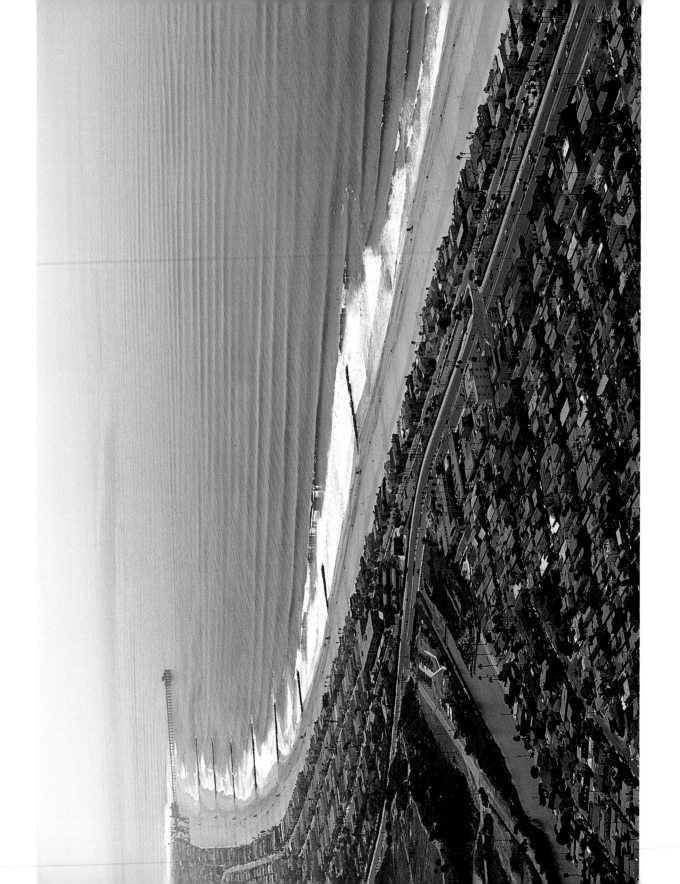

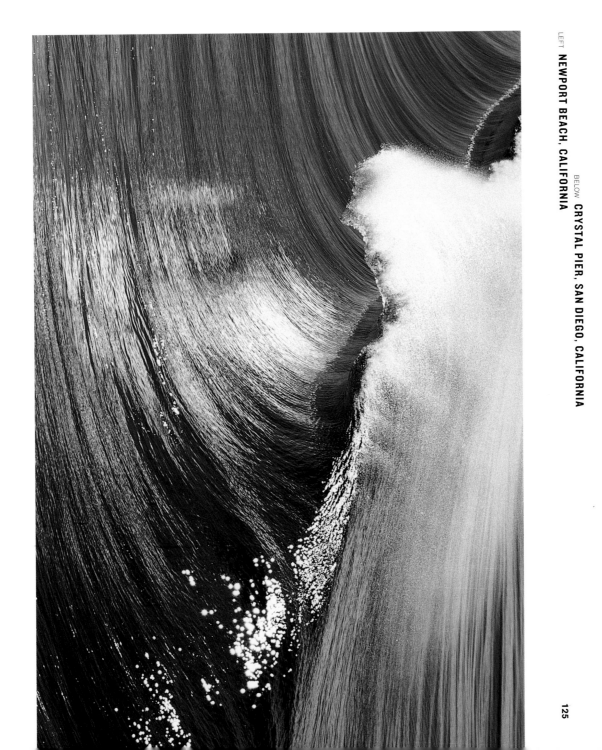

BELOW **CRYSTAL PIER, SAN DIEGO, CALIFORNIA**

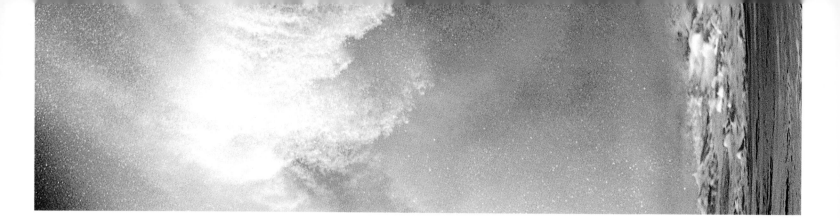

WAIMEA BAY, OAHU, HAWAII

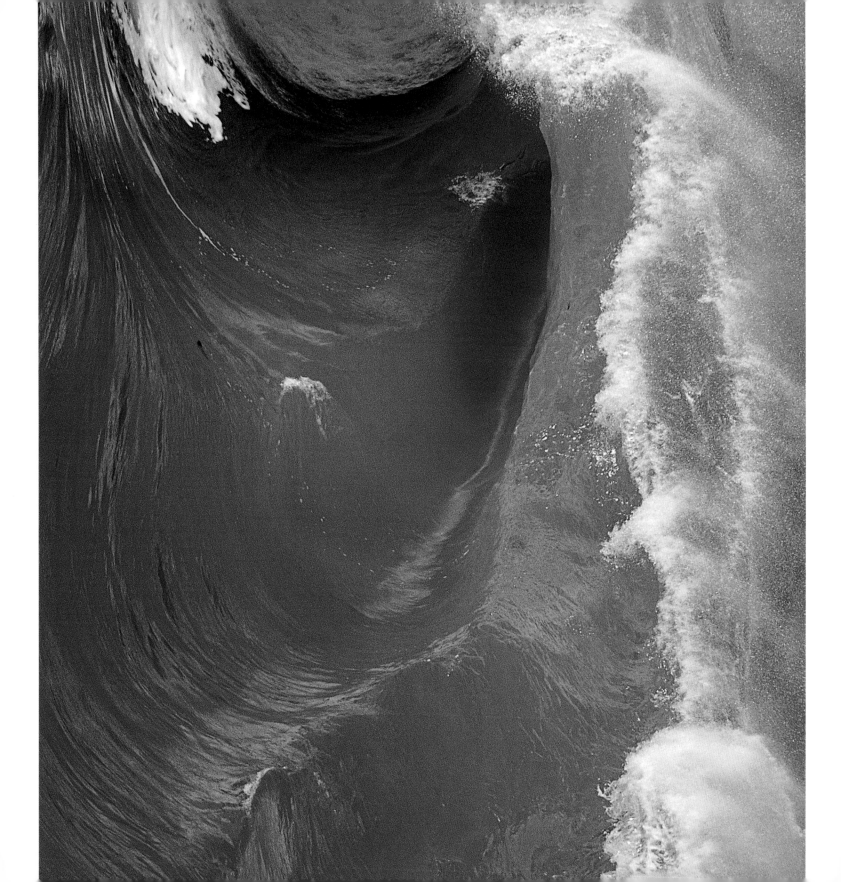

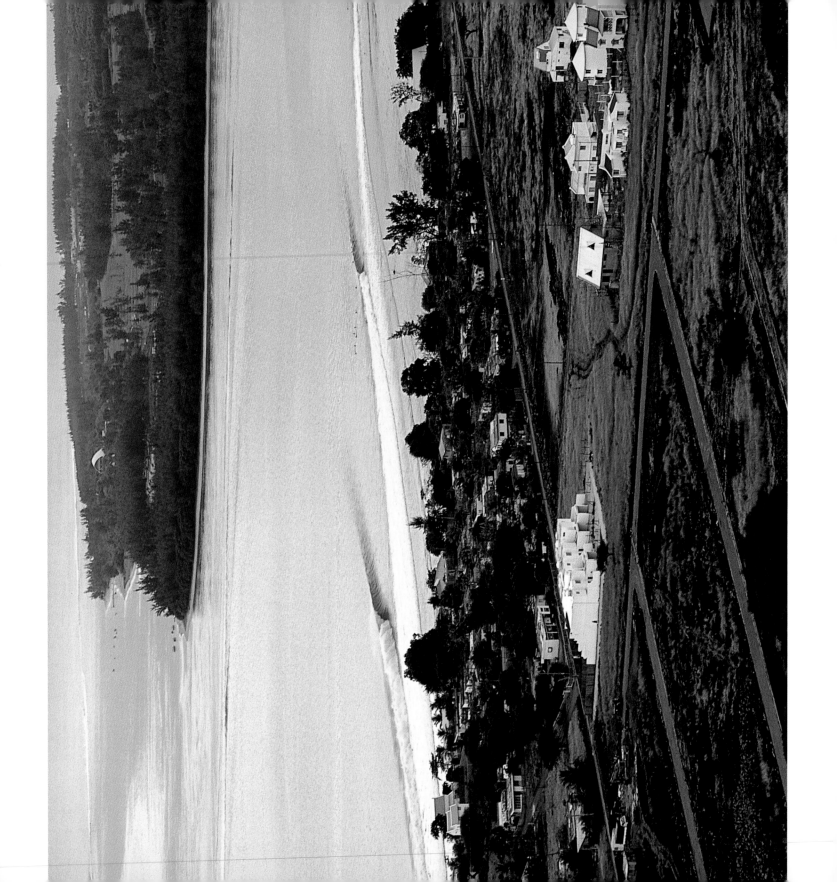

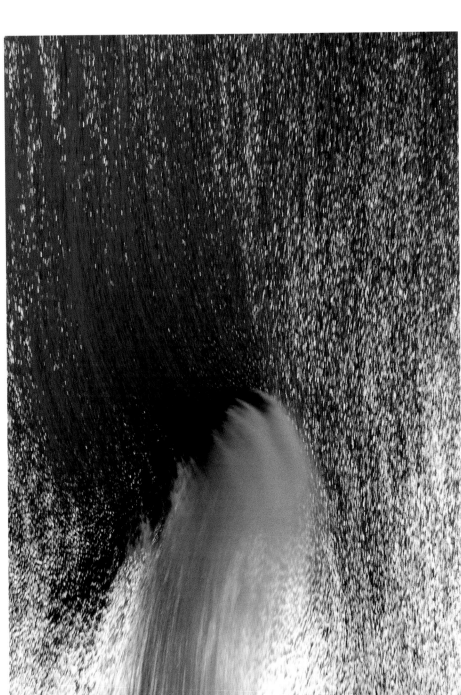

LEFT **TAMARIN BAY, MAURITIUS, AFRICA**

ABOVE **ZOOMERS, SANTA BARBARA COUNTY, CALIFORNIA**

BIBLIOGRAPHY

BASCOM, WILLARD. WAVES AND BEACHES.
GARDEN CITY, NEW YORK: ANCHOR BOOKS, 1964.

BUTT, TONY, AND PAUL RUSSELL. SURF SCIENCE: AN INTRODUCTION TO WAVES FOR SURFING.
PENZANCE, CORNWALL, U.K.: ALISON HODGE PUBLISHERS, 2002.

KAMPION, DREW. THE BOOK OF WAVES.
SANTA BARBARA, CALIF.: ARPEL GRAPHICS AND SURFER PUBLICATIONS, 1989.

KINSMAN, BLAIR. WIND WAVES: THEIR GENERATION AND PROPAGATION ON THE OCEAN SURFACE.
NEW YORK: DOVER PUBLICATIONS, 1965, 1984.

LANSING, ALFRED. ENDURANCE: SHACKLETON'S INCREDIBLE VOYAGE.
NEW YORK: CARROLL+GRAF PUBLISHERS, 1959.

WARSHAW, MATT. THE ENCYCLOPEDIA OF SURFING.
SAN DIEGO, CALIF.: HARCOURT, 2003.

ACKNOWLEDGMENTS

Thanks to Jeff Divine, Rob Gilley, Tom Servais, Art Brewer, Sean Davey, and Andrew Kidman for signing on to this project early and enthusiastically.

Thanks to Sean Collins for twenty years of surf-science tutorials.

Thanks to Matt Warshaw for fielding a dozen panicked phone calls, and for his indispensable *Encyclopedia of Surfing*.

Finally, thanks to Sarah Malarkey—editor, friend, hotdogger.

NEXT PAGE **OUTSIDE ALLIGATOR'S, OAHU, HAWAII**

131

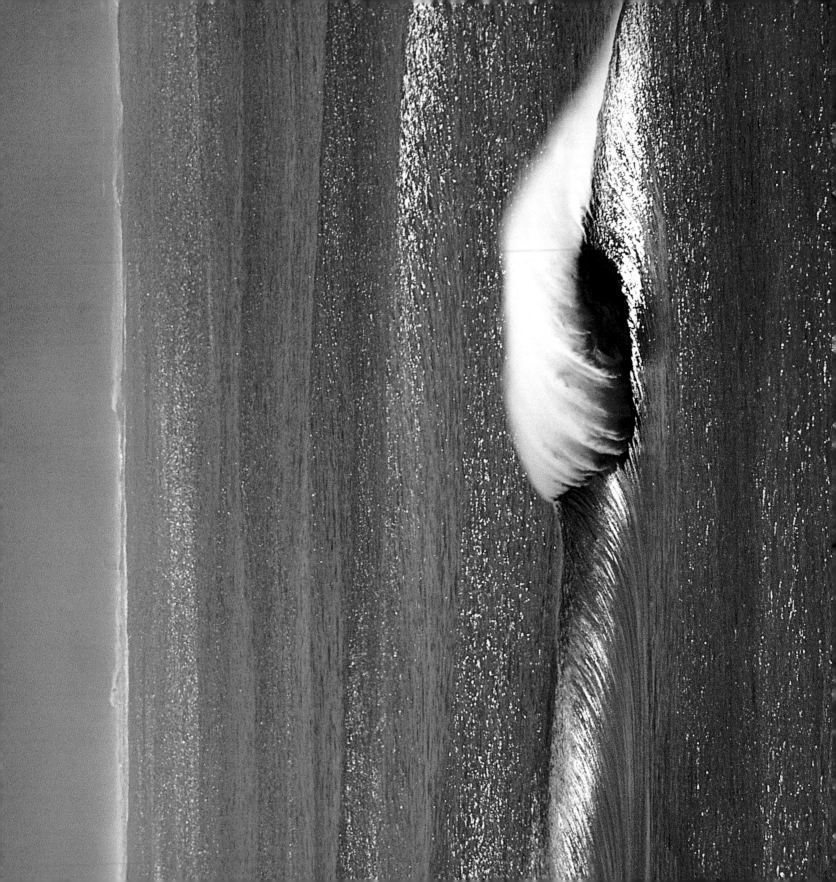